IMAGES
of America

THE JEWISH COMMUNITY OF NORTHERN VIRGINIA

D1597414

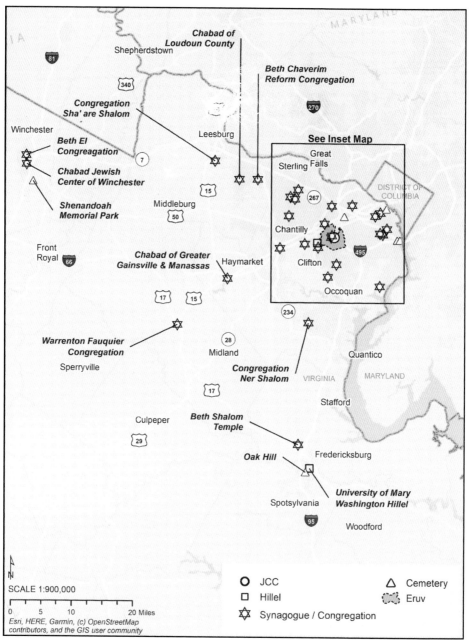

Chabad of
Loudoun County
Shepherdstown

Beth Chaverim
Reform Congregation

Congregation
Sha' are Shalom

Winchester

Beth El
Congreagation

Chabad Jewish
Center of Winchester

Shenandoah
Memorial Park

Leesburg

Middleburg

Front
Royal

Chabad of Greater
Gainsville & Manassas

Haymarket

Warrenton Fauquier
Congregation

Sperryville

Midland

Congregation
Ner Shalom

Culpeper

Beth Shalom
Temple

Oak Hill

Spotsylvania

Woodford

See Inset Map

Great
Sterling Falls

Chantilly

Clifton

Occoquan

Quantico

VIRGINIA MARYLAND

Stafford

Fredericksburg

University of Mary
Washington Hillel

MARYLAND

DISTRICT OF
COLUMBIA

N

SCALE 1:900,000

0 5 10 20 Miles
Esri, HERE, Garmin, (c) OpenStreetMap
contributors, and the GIS user community

O JCC △ Cemetery
□ Hillel Eruv
✡ Synagogue / Congregation

This map shows the location of selected sites of Jewish interest in Northern Virginia. The sites include synagogues, the Pozez Jewish Community Center, Gesher Jewish Day School, Hillel centers for college students, and Jewish cemeteries. Arlington National Cemetery is included because of the many uniquely Jewish memorials located there. (Courtesy of Jonathan M. Pickus.)

ON THE COVER: The M. Sher and Son general merchandise store is seen here around 1920. When Menasha and Esther Sher purchased the general store at the corner of Walter Reed Drive and Columbia Pike in 1918, there were very few Jews living in the area. Their daughter Ida married Sol Cohen, and the couple took over the store in the late 1920s. (Courtesy of the Center for Local History/Arlington Library.)

IMAGES
of America

THE JEWISH
COMMUNITY OF
NORTHERN VIRGINIA

Susan and Shawn Dilles
Foreword by Rabbi Daniel Novick

ARCADIA
PUBLISHING

Published by Arcadia Publishing
Charleston, South Carolina

Printed in the United States of America

Library of Congress Control Number: 2022938047

For all general information, please contact Arcadia Publishing:
Telephone 843-853-2070
Fax 843-853-0044
E-mail sales@arcadiapublishing.com
For customer service and orders:
Toll-Free 1-888-313-2665

Visit us on the Internet at www.arcadiapublishing.com

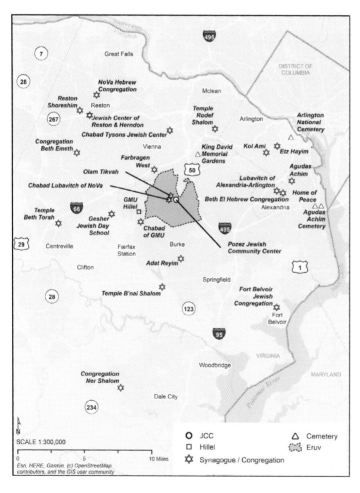

This map shows a close-up of selected sites of Jewish interest in the area near Fairfax County and Alexandria. It also shows the location of the mikvah, or ritual bath, and the area covered by the Fairfax Eruv, a ritual enclosure that facilitates some activities otherwise not permitted on Shabbat, the Jewish Sabbath. (Courtesy of Jonathan M. Picus and the Fairfax Eruv Committee.)

CONTENTS

FOREWORD

For much of its history, the communal narrative around Northern Virginia Jewry has been one of crossing the river into Maryland to meet Jewish needs. Yet this is not how my ancestors' history unfolded. Five generations prior, my family crossed the river in the opposite direction. In 1908, my great-great-grandparents Max and Nellie moved to Winchester, Virginia, hearing that it was a place with religious and economic opportunity. There, they found economic and educational possibilities and religious freedoms that Jews could enjoy. My family built a trucking business that, among other things, carried kosher food to Jews in the region. My family was active in establishing the synagogue in Winchester, and my grandfather Marshall, in his tenure as B'nai B'rith president, even dedicated the first Hillel House at the University of Virginia in 1943, the same one I frequented as a UVA student decades later.

Building a Jewish community in Northern Virginia is central to my Jewish identity. After meaningful experiences with local preschool, day camp, and religious school, I was particularly active in building my synagogue's United Synagogue Youth (USY) chapter. Though our regional meetings were in Maryland, over time, the USY chapter at Beth Emeth in Herndon, Virginia, became the region's most active—who thought that our Northern Virginia synagogue could house a USY Chapter of the Year? (Answer: we did.)

As we knew experientially, and as this book unequivocally demonstrates, this small and mighty Jewish community was never secondary to that of our neighbors. It was always vibrant, connected, and thriving. My great-great-grandfather Max called this place a land of religious opportunity. It certainly provided me, and the many whose narratives are present in this book, with meaningful Jewish opportunities. It provided us with connection and people—in my case, friends who I went to Jewish preschool with, who stood with me as groomsmen at my wedding, and who are now starting families alongside my own in this same area. And it provides me a home for my career, serving as a rabbi in the very community that invested so much in my growth and Jewish identity building.

As the executive director and rabbi at George Mason University Hillel, I am inspired every day to work with hundreds of students who call the Northern Virginia Jewish community home. With 70 percent of students remaining in Northern Virginia upon graduation, our Hillel is about ensuring the vibrancy and growth of our community well into the future. Our work is an investment in the next phase of Northern Virginia Jewry, so that it can provide to future generations what my ancestors provided me.

As we look toward this bright future, I am filled with such gratitude for Shawn and Susan Dilles for taking the rich narratives and history of this region and expertly shedding light on the variety of ways that Virginia Jews express their religious life. Northern Virginia Jewish life is, as you will see, lively, diverse, and growing.

—Rabbi Daniel Novick
Executive Director, George Mason University Hillel
rabbidaniel@masonhillel.org

ACKNOWLEDGMENTS

The authors would like to thank all of the local families, congregations, and organizations that provided us access to their stories, personal photographs, and community archives. We are also grateful for all of the assistance we received from everyone who has helped to enrich our photograph captions. Local photographers David Massarik and Lloyd Wolf were exceptionally generous with their time and allowed us to review and use many of their photographs. Cartographer Jonathan Pickus donated his skill and time to create the two maps of the area. Jonathan Edelman from the Capital Jewish Museum shared the museum holdings and provided a much-appreciated tour of the archives. We were humbled and inspired by the support we received from virtually every organization and congregation, especially in the midst of a pandemic. We gratefully acknowledge their support, and they are credited in the text.

We also want to acknowledge the assistance provided by Beth El Hebrew Congregation archivists Catherine Weinraub and Penny Weinstein from Temple Rodef Shalom, who each spent a day reviewing their congregational histories and archives. Rabbi Sholom Deitsch and Laura Adler both generously supported this project and provided full access to their personal and organizational photographs.

Hundreds of community members have shaped this book in large and small ways. Some have provided us with rarely seen photographs and information that helps tie together the story of our community. At the risk of inadvertently omitting some of these contributors, we express our appreciation to Paul Astrow, Rabbi Marvin Bash, Ann Bennett, Les Bergen, Debby Bruce, Bobbie Ebert, Dotty Fuchsman, Rabbi Steve Glazer, Rochelle Goldberg, Ellen Grady, Susan Kusel, Mark Lapidus, Julius Levine, Laurie Mangold, Ronald Markiewicz, Linda Marshall, David Massarik, Nessa Memberg, Bob Meyers, Howard Nachman, Rabbi Daniel Novick, Jim Robbins, Joan Sacarob, Lynne Sandler, Shana Spindler, Sue Kovach Shuman, Glenn Taubman, and Anita Turk.

We acknowledge the exceptional support received from libraries and local history collections in the area, and the professional researchers who assisted us: Alexandria Library, Local History/Special Collections (Brian Sando); Center for Local History, Arlington Public Library (Heather Crocetto and Judith Knudsen); Herndon Historical Society (Barbra Glakas); Library of Congress Photograph Collection; Lillian and Albert Small Capital Jewish Museum; Mary Riley Styles Public Library, Local History Collection, Falls Church, Virginia; Stewart Bell Jr. Archives Room, Handley Regional Library, Winchester (Bettina Helms); and Thomas Balch Library, Leesburg, Virginia (Laura E. Christiansen).

Finally, our thanks go to Caroline (Anderson) Vickerson of Arcadia Publishing for her professionalism and patience, which helped the authors produce this book during the COVID pandemic.

INTRODUCTION

The Northern Virginia Jewish community made headlines in 2018 when a population survey of Washington area Jews revealed that Northern Virginia had surpassed the District of Columbia and the Maryland suburbs with the region's largest Jewish population. The comprehensive survey determined that Virginia was home to over 120,000 Jews, up dramatically from a 2003 estimate of 68,000. The number is higher than in most metropolitan Jewish communities in the United States. In fact, the number is larger than the combined Jewish populations of Belgium, Italy, Spain, Denmark, Poland, Portugal, Luxembourg, India, Greece, and the Netherlands. One local rabbi was quoted as saying, "It speaks strongly for the richness and breadth of Jewish life in Northern Virginia. We're there, and there are a lot of us."

When we moved to Washington in the early 1980s, one of our parents provided us with advice we have never forgotten: "Jews don't go to Virginia." Fortunately, we didn't listen to it. We became confident of our choice after a few hours of pre-internet research showed that we could find a home within 15–20 minutes of four different synagogues and the Jewish Community Center (JCC). The quality of life in the Virginia suburbs is excellent, and we still love the area nearly 40 years later.

By the 1990s, synagogues began popping up all around the region, the JCC opened a large new facility, Gesher Jewish Day School made plans for a large new campus, and public Hanukah lighting ceremonies became common. Clearly, there was a lot more going on in Jewish Northern Virginia than many people realized—even those in the local Jewish press and (primarily) Maryland-based community support organizations. It did not come as a surprise when the leaders of the new population survey conceded that the 2003 survey likely undercounted the number of Jews in Northern Virginia.

We waited for decades for someone to write a book like this one, but apparently, the Northern Virginia Jewish community has remained under the radar of local authors as well. Retirement and the COVID pandemic provided us time to explore a bit of the vibrant history of our Jewish community. We did not intend to write an academic or sociological study, nor a comprehensive history. We affectionately think of this book as a community scrapbook that reflects how Jews in Northern Virginia worked, prayed, organized congregations, and built a multifaceted community during the last 160 years.

Many of the photographs and stories we uncovered were like the tips of icebergs, signaling that there is so much more to tell and that some details may already be gone forever. A few intrepid researchers have shown how it is possible to piece together a history that would otherwise be lost, like Ruth Singer for Alexandria and Nessa Memberg for Leesburg. If this book encourages others to help record and remember their stories and photographs, or to research the many aspects of Jewish life in Northern Virginia, we say, "*yasher koach*." Perhaps the time has come to establish some form of Northern Virginia Jewish Historical Society to record and remember the tapestry of Jewish life here.

The Jewish Community of Northern Virginia extends from Alexandria in the east to Winchester in the west, and south to Fredericksburg and Warrenton. Small numbers of Jews have lived in the area since the early days of the colonial period. A year before the city of Washington, DC, was

founded in 1790, the first Virginia synagogue had already been established in Richmond. The next closest Jewish community was in Baltimore, where the first synagogue was formed in 1845.

The major external factors that shape the Northern Virginia Jewish community have been wars, immigration, and the growth of the federal government. In 1848, a series of revolutions in Germany and central Europe fueled a surge in emigration from those areas. German Jews entered the country through ports of entry such as New York, Baltimore, Norfolk, Savannah, and Charleston, and many settled in those areas. In Virginia, the German Jews settled primarily in Richmond, Norfolk, Petersburg, and Alexandria. Some German Jews—many peddlers and merchants—also settled in smaller towns across the state.

These German immigrants formed the first Jewish community in Alexandria, in the late 1850s, on the eve of the Civil War. The fortunes of the Jewish communities in Alexandria and Washington, DC, were reversed in the aftermath of that war, with the District's population and economy expanding greatly while Alexandria struggled for years to fully recover. Alexandria's Jewish community remained intact through the war and slowly grew, but a second viable congregation did not take root for over 50 years.

Between 1880 and 1924, large numbers of Jews arrived from Eastern Europe and Russia, driven by repressive laws, increasingly violent anti-Semitic attacks, and war. Many of the newcomers filled tenements in the Lower East Side of New York and settled in other large cities. Not all went to urban areas, and it may be surprising how many Jews settled in small towns across Virginia at this time. We have come across records of Jewish merchants in Alexandria, Arlington, Fredericksburg, Herndon, Manassas, Leesburg, Culpeper, Marshall, and Winchester. Further research would undoubtedly turn up many more; for example, in Fairfax, Warrenton, and elsewhere. Immigrants from this wave formed Agudas Achim in Alexandria in 1914. Other communities were bolstered by the new arrivals, and their children and grandchildren later helped form new congregations across the region.

During the presidency of Franklin Roosevelt, the federal government grew and new jobs were created in the area. World War II drove more growth in Virginia, including but not limited to the Pentagon in Arlington. The Arlington Jewish Center—later renamed Ar-Fax Jewish Congregation and now Etz Hayim—was formed in 1940. In the 1950s and 1960s, this synagogue sat at a crossroads between the long-established community in Alexandria and the increasing number of Jews who were venturing farther west. Jewish organizational, cultural, and philanthropic life flourished in the area between Ar-Fax and Agudas Achim during the postwar boom years. Many of the communal activities were focused on addressing the challenges posed by the Israel War of Independence, the absorption of Jewish refugees from postwar Europe and the Arab world, and the 1956 and 1967 Arab-Israeli conflicts. The Jewish War Veterans organization was very active in the years after World War II and the Korean War. Hadassah, the Women's Zionist Organization of America; ORT (Organization for Rehabilitation through Training); HIAS (Hebrew Immigrant Aid Society); Jewish National Fund, B'nai B'rith; National Council of Jewish Women, along with synagogue Sisterhoods and Brotherhoods (later Men's Clubs), were constantly meeting and mingling. During this period, congregations also formed in Fredericksburg and Winchester. Nearby, Fort Belvoir established a Jewish congregation led by military chaplains.

By the 1960s, Jews in Fairfax County found it difficult to commute to Alexandria and Arlington for religious school and services. New congregations formed in Falls Church (Reform congregation Rodef Shalom) and Fairfax (Conservative congregation Olam Tikvah) that quickly grew to become some of the largest in the state. Just 10 years later, the Northern Virginia Hebrew Congregation (Reform) and Congregation Beth Emeth (Conservative) formed farther west in Reston and Herndon.

Two women in the mid-1960s decided that their children should not have to go out of the state to attend Jewish summer camp, and so they formed Camp Achva. Camp Achva played an important and perhaps underappreciated role in the development of Northern Virginia's Jewish community. Children from synagogues across much of the area attended the camp, forming friendships and bonds that lasted a lifetime. Synagogues cooperated to support the camp, taking turns hosting it in its early years. In the fall of 1969, on the heels of the first season of Camp Achva, 14 Northern

Virginians (many with children at Achva) met to discuss establishing a Jewish community center. Up until that time, the area had been served by outreach programs based at the JCC of Greater Washington in Rockville, Maryland. One Achva parent suggested purchasing the tiny house on Little River Turnpike that became the first home of the JCC. When the Gesher Jewish Day School started in 1982, it followed a path similar in many ways to Camp Achva.

The Jewish Community Center was officially incorporated on May 9, 1980. The center housed several Jewish social service organizations and served as the home base for Camp Achva and later Gesher Jewish Day School. Since 1990, when the current JCC building opened, the center has offered a wide range of activities and services for members and the community at large. The JCC has added a major new dimension to Jewish life in the area and serves as a hub for cultural, educational, and recreational activities.

From the 1980s to 2005, congregations continued to sprout in southern and western Fairfax County, in Prince William, Loudoun, and Winchester. The congregation in Fredericksburg moved a few miles north to Stafford County. Two congregations are in leased space (Beth Chaverim Congregation in Ashburn and Temple Beth Torah in Chantilly). The most recent addition is the Fauquier Jewish Congregation. Several small groups called *havurah* (plural: *havurot*) also gather regularly including the Reston Shorshim and Fabrengan West groups. Finally, the Kol Ami Northern Virginia Reconstructionist Community was formed in Arlington in 2000.

The options for Jewish religious expression in Northern Virginia have continued to increase over time. From 1859 to 1914, Reform was the only synagogue option. Agudas Achim was Orthodox from 1914 to 1945, then became Conservative. While there have been Orthodox religious services and even regular minyan groups between 1945 and 1990, they are not well documented, and none seem to have grown to where they had a permanent building. In 1991, the Chabad Lubavitch of Northern Virginia opened in rented space in Fairfax. Since then, Chabad has expanded from its Fairfax headquarters across Northern Virginia, from Alexandria-Arlington all the way to Winchester. Finally, a few congregations are not affiliated, including Adat Reyim, which has chosen this path since its inception.

It took over 100 years for Reform and Conservative congregations to form across Northern Virginia, and in the last 30 years, Chabad has established Orthodox congregations across most of the same area. Today, there are Chabad Jewish Centers in Alexandria-Arlington, Fairfax, George Mason University, Tyson's Corner, Reston-Herndon, Gainesville, Ashburn, and Winchester. Chabad of Northern Virginia constructed the first mikvah and was instrumental in creating the first eruv in the region. Its outreach events include religious and cultural programs that enrich Jewish life for many. Chabad is providing opportunities for traditional forms of Jewish expression that have not been seen in the area for decades.

All signs point to continued growth in the coming years. No longer under the radar, the Northern Virginia Jewish community today provides a wide range of cultural, educational, and religious opportunities for expression. We are happy to be witnesses to this tremendous growth.

One

A COMMUNITY OF JEWS FORMS A JEWISH COMMUNITY

ALEXANDRIA AND BETH EL HEBREW CONGREGATION

Small numbers of Jews have lived in Virginia since colonial times. In 1848, a series of revolutions began against European monarchies, beginning in Sicily and spreading to France, Germany, Italy, and the Austrian Empire. The turmoil sparked a wave of immigration to the United States, which included many Jews. Simon Blondheim (1834–1901) departed Germany, and in 1850 opened a clothing store at the corner of King and Fairfax Streets in Alexandria. He helped organize the first Jewish community organizations in Northern Virginia and served as the first president of Beth El Hebrew Congregation. A sixth-generation Blondheim descendent is now a member of Beth El. (Courtesy of the Beth El Hebrew Congregation Archive.)

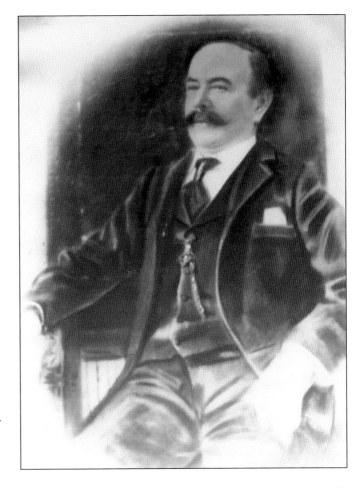

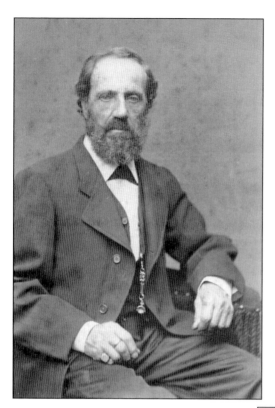

Joseph Brager and his wife, Isabel, also left Germany and settled in Alexandria. They were members of Beth El, and Joseph served as treasurer in 1874. He is pictured here around 1910. (Courtesy of the Beth El Hebrew Congregation Archive.)

Many of the Jews who settled in Alexandria were merchants selling clothing, shoes, jewelry, or other merchandise. Joseph Brager and his son-in-law Emanuel Goldsmith ran a clothing shop in this building at 108 King Street in the late 1800s and early 1900s. Today, the building is home to an ice-cream and custard creamery, and the name "E. Goldsmith" is still visible at the top of the building. (Courtesy of the Library of Congress.)

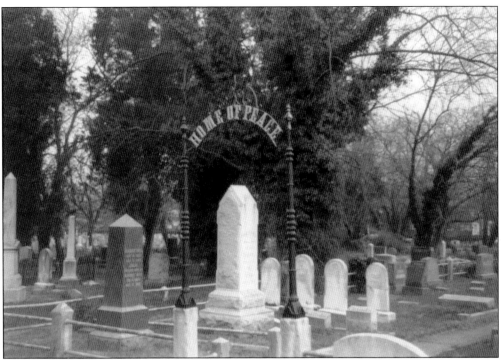

About 50 Jewish families lived in Alexandria by 1857. In that year, a group of prominent citizens established the Hebrew Benevolent Society—two years before founding Beth El Hebrew Congregation—making the society the first Jewish community organization in Northern Virginia. The society bought land south of Payne Street near the intersection with Franklin for the Home of Peace Cemetery, shown here in 1987. It remained an independent institution until 1983, when it affiliated with Beth El Hebrew Congregation, and it remains active today. (Courtesy of Ruth Singer and the Alexandria Library Local History/Special Collections.)

The Home of Peace Cemetery holds the remains of many of the early German Jewish immigrants who settled in Alexandria and some from later generations of Eastern European and American-born Jews. Generations of Beth El members are interred at the cemetery, as well as a few others who were cared for by the Hebrew Benevolent Society. (Authors' collection.)

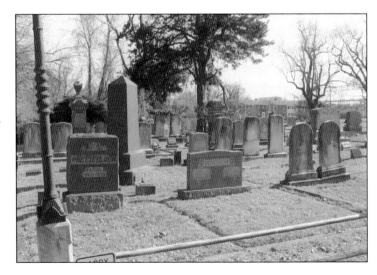

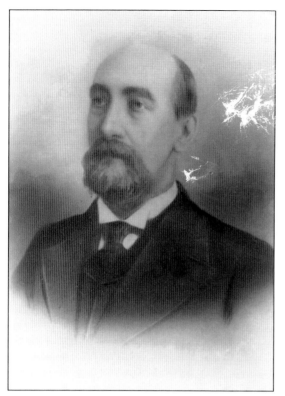

Isaac Eichberg (1830–1914) is shown in this c. 1900 photograph. Eichberg was the second president of Beth El Hebrew Congregation after Henry Blondheim. He served a series of terms totaling over 35 years, with the first in 1864 and the last in 1914. (Courtesy of the Beth El Hebrew Congregation Archives.)

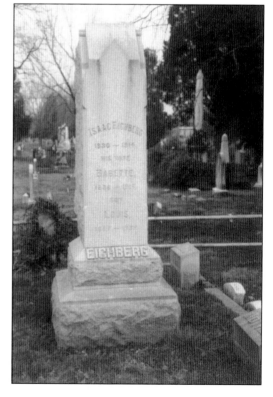

This 1987 photograph from the Home of Peace Cemetery in Alexandria shows the tombstone of Isaac Eichberg and his wife, Babette. Other early leaders of the Alexandria Jewish community are buried nearby, including Joseph Brager, Simpson Dreifus, Henry Strauss, and Arnold Ettinger. For over seven decades, Home of Peace was the only Jewish cemetery in Northern Virginia. (Courtesy of the Alexandria Library Local History/Special Collections.)

14

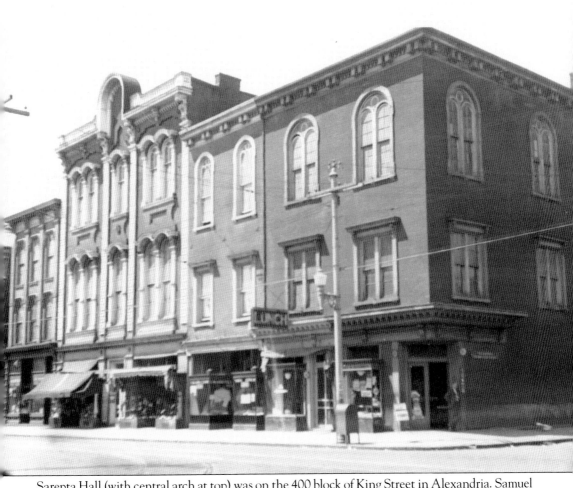

Sarepta Hall (with central arch at top) was on the 400 block of King Street in Alexandria. Samuel Rosenberg (1879–1930) bought the building and ran a department store on the first floor. The upper floor housed an auditorium with a stage, curtain, and theatrical décor. Shown here in 1935, the hall was used by congregants of Beth El, and later of Agudas Achim, to hold services before their synagogues were constructed. The building was eventually demolished as part of an urban revitalization effort. (Courtesy of the Alexandria Library Local History/Special Collections.)

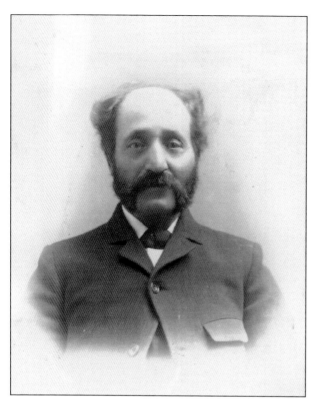

The Bendheim family was associated with Beth El for over 100 years. Leopold Bendheim (1830–1903) was a founding member of Beth El, as well as the father of Charles Bendheim and the grandfather of Leroy Bendheim. This c. 1890 photograph shows Leopold Bendheim. (Courtesy of the Beth El Hebrew Congregation Archives.)

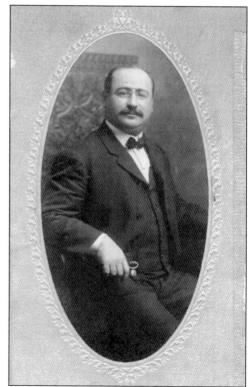

Charles Bendheim (1866–1934) is shown in this c. 1900 photograph. He served in the Virginia House of Delegates representing the Alexandria area. (Courtesy of the Beth El Hebrew Congregation Archives.)

Leroy Bendheim (1906–1987) was an active member of Beth El and served as president from 1954 to 1962. He also served two terms as mayor of Alexandria and three terms as a Virginia state senator. This photograph was taken around 1960. (Courtesy of the Beth El Hebrew Congregation Archives.)

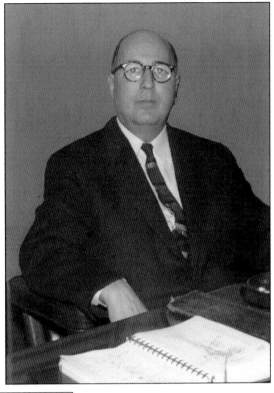

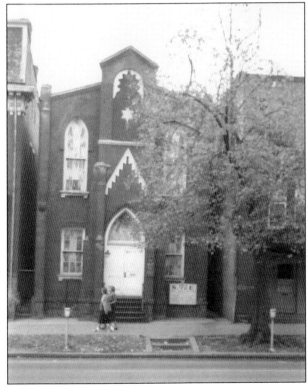

Beth El Hebrew Congregation was founded in 1859, two years after the establishment of the Hebrew Benevolent Society. The first permanent home of the congregation was on the 200 block of Washington Street. Construction began on June 26, 1871, and the building was dedicated on September 1. A stone marker was made to commemorate the dedication. The stone is in the shape of a Star of David (Magen David) and reads, "Beth El Dedicated Sept. 1 1871"; it is on display in the Beth El lobby. This building served the congregation until 1954. A new synagogue at 3830 Seminary Road was dedicated in 1957. This photograph was taken in 1958. (Courtesy of the Alexandria Library Local History/Special Collections.)

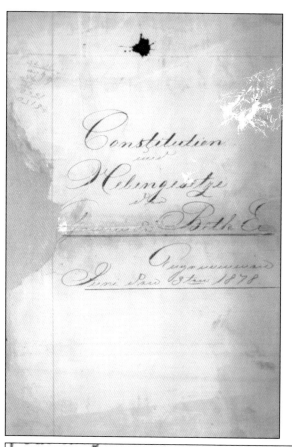

The earliest known version of a constitution for Beth El Hebrew Congregation was written in German in 1878. Today, the document is in the synagogue archives on Seminary Road. (Courtesy of the Beth El Hebrew Congregation Archives.)

In 1876, Alexandria Jews established the B'nai B'rith Mount Vernon Lodge 259. The men's fraternal organization was founded in New York in 1843, and lodge activities focused on mutual aid, social service, and philanthropy. The Mount Vernon chapter was the first in Northern Virginia, and the members' names reflect their German origins. This announcement for a grand ball appeared in the *Alexandria Gazette* on April 11, 1876. The Mount Vernon lodge remained active until 1905. (Courtesy of the Library of Virginia/*Virginia Chronicle*.)

FIRST GRAND BALL

FOR THE BENEFIT OF

Mount Vernon Lodge, No. 259,

(I.O.B.B.)
At HARMONIE HALL,
WEDNESDAY EVENING, APRIL 12, 1876.

Committee of Arrangements.

H. Strauss,	M. Ruben,	E. Goldsmith,
H. Schloss,	S. Blondheim,	M. Bendheim,

Cards $1, admitting a gentleman and ladies.
ap 3 —td

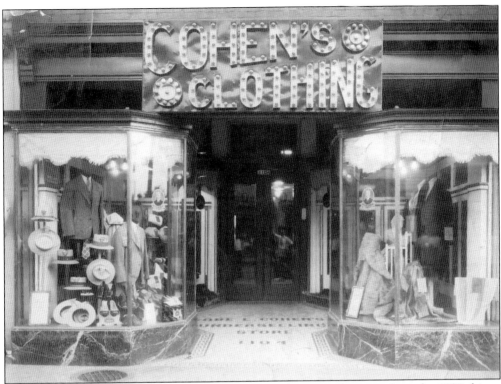

Eastern European Jews began to immigrate to the United States in large numbers after 1880, driven by oppressive legislation, poverty, and violent anti-Semitism. They were attracted to America by the hope of financial advancement and religious freedom. Abe Cohen's clothing store flourished at 1104 King Street in Alexandria from the early 1900s until closing in 1968. During that time, the name evolved from Abe L. Cohen's Underselling Store to Cohen's Clothing, to Cohen's Quality Shop. The dynasty continues today with Joel Cohen, who recently celebrated the 50th anniversary of the Crystal Boutique clothing store he founded in Arlington in 1970. (Courtesy of the Alexandria Library Local History/Special Collections.)

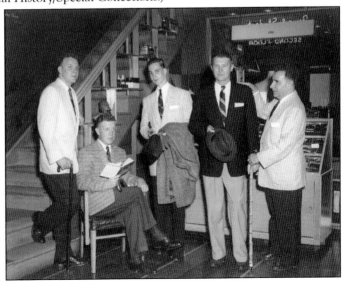

When Abe Cohen retired, the store was taken over by sons Sidney and Sylvan. Well-dressed men pose in this photograph taken inside the store in 1955. Sylvan Cohen is standing at far right with the cane. (Courtesy of the Alexandria Library Local History/ Special Collections.)

Joseph Hayman (born Hait, 1880–1964) emigrated from Latvia in 1902 and started a small variety shop at 188 North Royal Street. The business grew into a 90-year retail dynasty, peaking with Hayman's popular ladies' wear store, shown in this c. 1968 photograph. (Courtesy of the Library of Congress.)

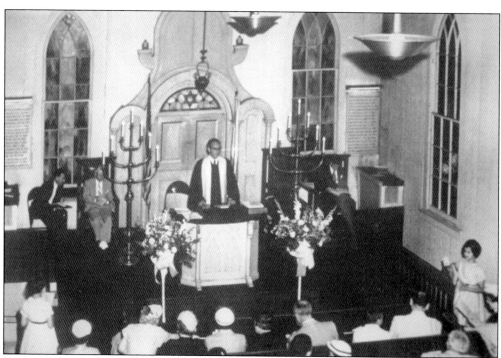

Rabbi Emmet A. Frank served at Beth El from 1954 to 1969 during a time of rapid growth in membership and the transition to a new synagogue building on Seminary Road. Rabbi Frank is seen here officiating at a service at the Washington Street synagogue in 1954. (Courtesy of the Beth El Hebrew Congregation Archives.)

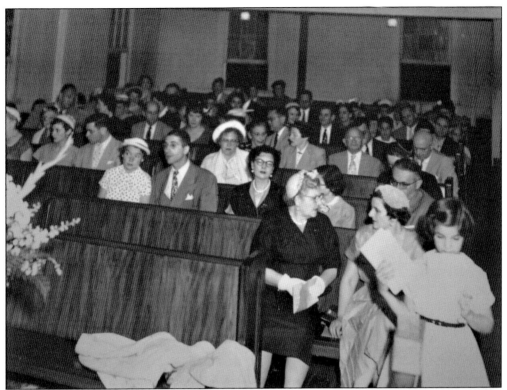

Beth El congregants gather for a Shabbat (Sabbath) service in this 1954 photograph. By the mid-1950s, the congregation had grown beyond the capacity of the Washington Street location, and plans were underway to raise funds for a new building. (Courtesy of the Beth El Hebrew Congregation Archives.)

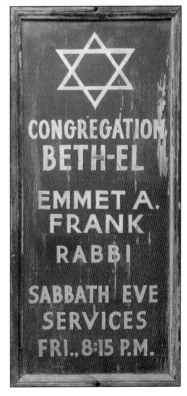

Rabbi Frank was an outspoken advocate for civil rights and received national press attention after a bomb threat on October 19, 1958. The rabbi had strong support from some local church leaders and never curtailed his messages advocating for civil rights. This sign showing the schedule of Rabbi Frank's services was taken from the synagogue's Washington Street location. (Courtesy of the Beth El Hebrew Congregation Archives.)

Beth El's congregation outgrew its Washington Street building after more than 80 years. After years of planning and fundraising, a new synagogue was dedicated in 1957 at 3830 Seminary Road. The new building, shown here in 1958, housed the rapidly growing congregation and its Hebrew School. (Courtesy of the Beth El Hebrew Congregation Archives.)

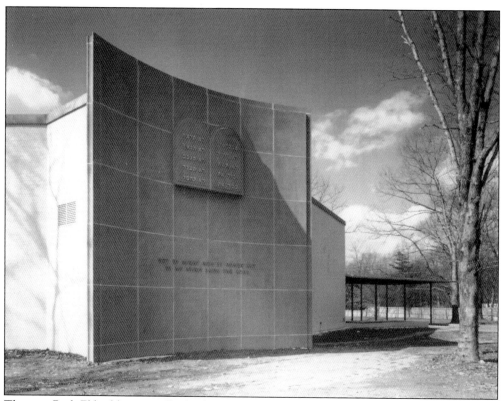

The new Beth El building proudly displays two tablets with the Ten Commandments written in Hebrew in this c. 1957–1958 photograph. Below the tablets is a biblical quote: "Not by Might Nor by Power but by My Spirit Saith the Lord." (Courtesy of the Beth El Hebrew Congregation Archives.)

Two

New Arrivals, New Practices

Agudas Achim Congregation Introduces Orthodox and Conservative Judaism

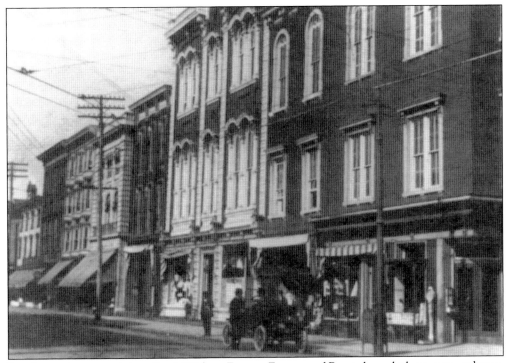

Jewish immigrants arriving after 1880 from Eastern Europe and Russia brought languages, cultures, and some religious practices that differed from those of the earlier Central European immigrants and their American descendants. In 1914, differences in religious practices led 14 families to separate from Beth El Hebrew Congregation and form the Orthodox congregation Agudas Achim. Sam Rosenberg, a founding member of Agudas Achim, owned the building housing Serapta Hall. He let the congregation use the hall as their first meeting place. The auto and electric poles suggest this photograph was taken around 1918. (Courtesy of the Beth El Hebrew Congregation Archives.)

In the early days of Agudas Achim, a small group departed and formed another Orthodox congregation named Beth Israel. The new congregation took out a mortgage on "the old Marshall house" at the southwest corner of Wolfe and Pitt Streets. During the Civil War, the structure served as a hospital. When the two congregations merged in 1928 under the name of Agudas Achim, the house at 508 Wolfe Street became the combined congregation's home. This photograph was taken in 1937. (Courtesy of the Alexandria Library Local History/Special Collections.)

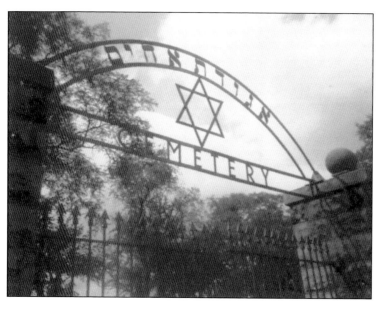

Agudas Achim Congregation purchased land for a Jewish cemetery south of Payne Street near the intersection with Jefferson Street in 1932, a block away from the Beth El cemetery. This 1985 photograph shows the gateway to the cemetery with the words "Agudas Achim" in Hebrew above a Magen David. (Courtesy of Agudas Achim Congregation.)

This contemporary photograph of the cemetery shows headstones featuring many Jewish symbols and Hebrew inscriptions. Several pebbles can be seen atop some of the headstones. It is a common Jewish custom to place a pebble on the headstone when visiting to pay respects to the deceased. (Authors' collection.)

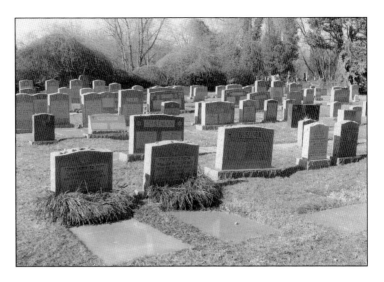

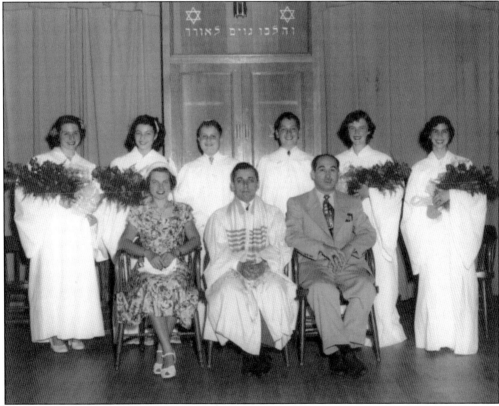

Agudas Achim has long maintained a robust religious school. This photograph shows a graduating confirmation class in the early 1950s. The students are dressed in white and standing in front of an ark holding the Torah scrolls, with the eternal light centered above the ark. Seated on the far right is teacher Jerome Salkin. The Hebrew reads, "And Nations Shall Walk by Your Light" (Isaiah 60:3). In the same year, the congregation voted to change from Orthodox to Conservative religious practice. (Courtesy of Agudas Achim Congregation.)

Members of Agudas Achim helped charter B'nai B'rith Alexandria Lodge 1555 in January 1945. The lodge was named for Maurice D. Rosenberg (1909–1950), a respected Alexandria resident, four-term member of the Virginia House of Delegates, and a former president of Beth El. This was the first B'nai B'rith lodge in Alexandria since 1905, when Mount Vernon Lodge No. 259 became inactive. (Courtesy of Agudas Achim Congregation.)

B'nai B'rith Lodge 1555 put on an annual fundraising comedy show in the late 1940s known as the Bowery Frolics. This photograph shows the cast of the 1948 Frolics on stage in costume. (Courtesy of Agudas Achim Congregation.)

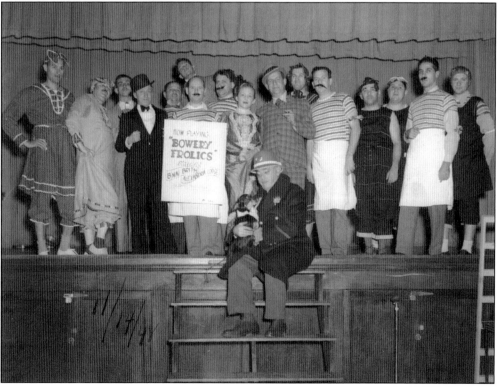

World War II brought rapid growth, new jobs, and new residents to Northern Virginia. In the 1940s, the Pentagon was constructed in Arlington, and the number of local federal government workers swelled along with the ranks of military personnel. Agudas Achim's congregation also grew rapidly and began the search for a new home. In 1947, the congregation left 508 Wolfe Street and moved to a more spacious and attractive building at 1400 Russell Road in Alexandria. (Courtesy of Agudas Achim Congregation.)

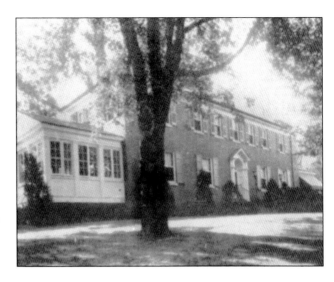

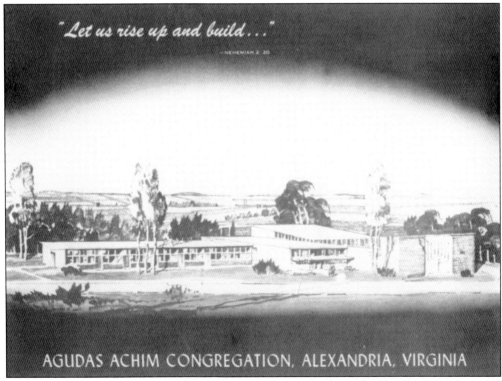

"Let us rise up and build..."

—NEHEMIAH 2:20

AGUDAS ACHIM CONGREGATION, ALEXANDRIA, VIRGINIA

The search for a new location and larger home began anew by the mid-1950s. By November 1955, the congregation had purchased a parcel of land on Valley Drive in Alexandria. An architect was commissioned to design the facility, and this sketch was prepared as part of the fundraising effort to support building construction. The biblical quote from Nehemiah refers to rebuilding the Temple in Jerusalem and served as the slogan for the new building effort. (Courtesy of Agudas Achim Congregation.)

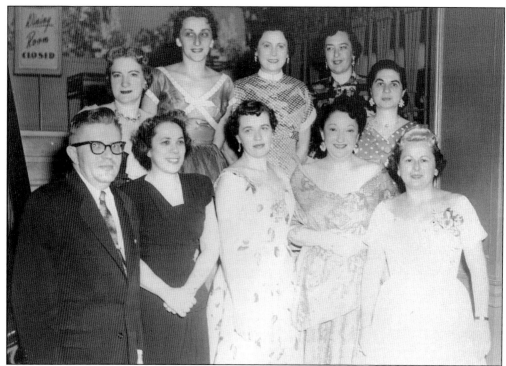

Agudas Achim maintained a range of groups and activities to provide members opportunities to participate and socialize. These photographs from 1955–1956 show the leaders of the Sisterhood (above) and Brotherhood, later Men's Club (below). Above, the tall woman in the second row, second from left, is Mollie Abraham. Below, the man in the first row at far left with his head tilted is Joseph Kleinman. Next to him is Bob Lainof. In the first row, far right, is Dan Kerbel. Phil Shapiro stands below the man at top left. (Both, courtesy of Agudas Achim Congregation.)

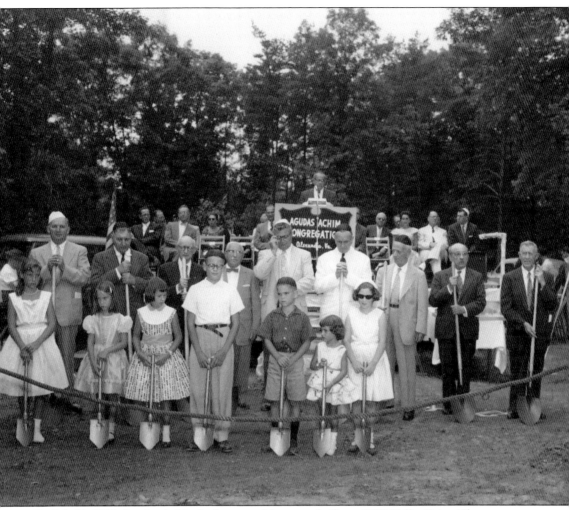

On July 22, 1956, Agudas Achim broke ground for a new facility at 2908 Valley Drive. The ceremony was a communal event attended by local officials, church leaders, and the press. Standing behind the children are, from left to right, unidentified, Sam Fagelson, Goodman Rubin, Dan Kerbel, and Bob Lainof in center, adjusting his glasses. The remaining participants are unidentified. (Courtesy of Agudas Achim Congregation.)

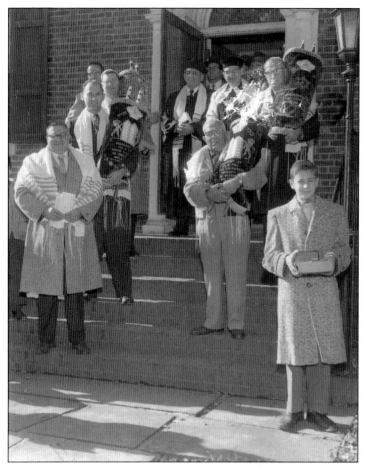

On March 30, 1958, the new synagogue building was completed, and the congregation held a ceremony to carry the Torah scrolls to the new building. Carrying a Torah scroll is considered an honor. This photograph shows leaders of the synagogue at Russell Road carrying the scrolls at the beginning of the journey to the new building. Bob Lainof is at far left in the first row. (Courtesy of Agudas Achim Congregation.)

This 1960 photograph shows congregants during the harvest festival of Sukkot. They are standing in a sukkah, or temporary booth, constructed for the holiday and decorated with autumn gourds and fruit. During the holiday, congregants share a meal inside the sukkah. Standing in the second row, third from right, is religious school director Sol Rabinowitz. (Courtesy of Agudas Achim Congregation.)

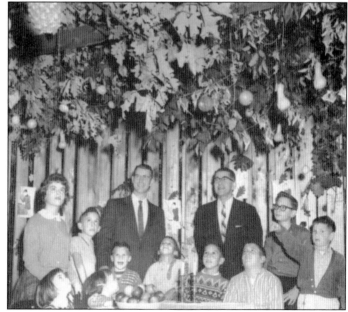

The Agudas Achim religious school held classes for students through their teen years. Shown in this photograph is the confirmation class of 1967–1968. Sol Rabinowitz is standing at far left. (Courtesy of Agudas Achim Congregation.)

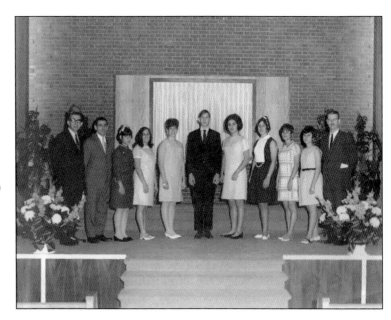

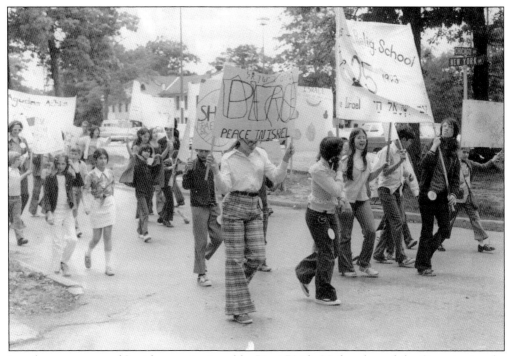

Local synagogues and Jewish organizations like B'nai B'rith, Hadassah, and the Organization for Rehabilitation through Training often held Israel-related fundraisers and educational activities. Events in the Middle East, such as the 1956 Suez Conflict, the 1967 Six-Day War, and the 1973 Yom Kippur War, increased the focus and attention of the Jewish community on Israel's safety and economic plight. Agudas Achim Religious School students are seen here holding an Israeli Independence Day celebration in May 1973 for Israel's 25th anniversary, just months before the Yom Kippur War in October. (Courtesy of Agudas Achim Congregation.)

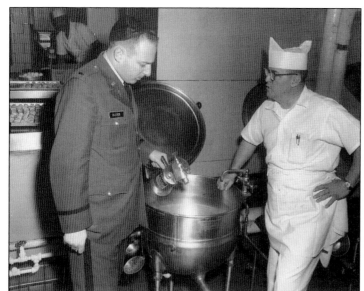

Prior to serving at Agudas Achim, Rabbi Sheldon Elster was an active-duty Jewish chaplain. In this photograph, First Lieutenant Elster inspects the kitchen in the Virginia Room of the Non-Commissioned Officers Club before hosting a Passover Seder at Fort Lee, Virginia, on March 27, 1964. (Courtesy of the Capital Jewish Museum.)

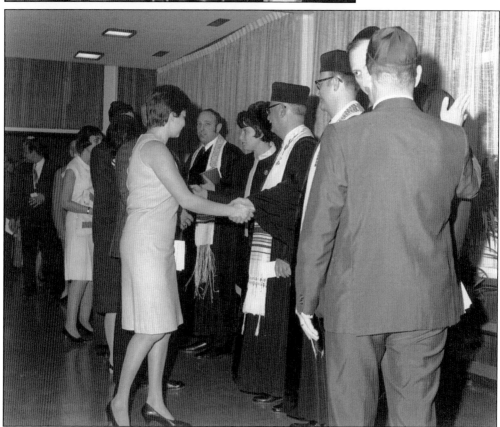

This photograph was taken at the installation of Rabbi Sheldon Elster on August 23, 1968. Standing from left to right are Rabbi Sheldon Elster (looking at camera), Dr. Shulamith Elster, Rabbi Paul Reich, Rabbi Seymour Essrog, and Agudas Achim president Dr. Bernard Stier. (Courtesy of the Capital Jewish Museum.)

Clergy members are shown during the installation ceremony for Rabbi Sheldon Elster at Agudas Achim in 1968. From left to right are Rabbis Paul Reich, Seymour Essrog, and Sheldon Elster. (Courtesy of Agudas Achim Congregation.)

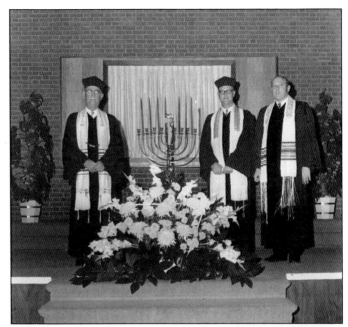

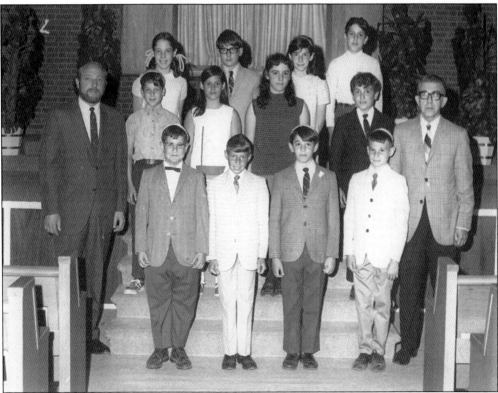

This is the Agudas Achim B'nai Mitzvah class of 1973. From left to right are (first row) Rabbi Sheldon Elster, ? Feldman, Jeff Shapiro, unidentified, Ira Witkir, and Sol Rabinowitz; (second row) ? Kline, Lisa Bondareff, Sharon Krevor, and unidentified; (third row) Rabbi Sheldon Elster, Horwick, Mitchell Stier, Andrea Rubin, and Shelley Kline. (Courtesy of the Capital Jewish Museum.)

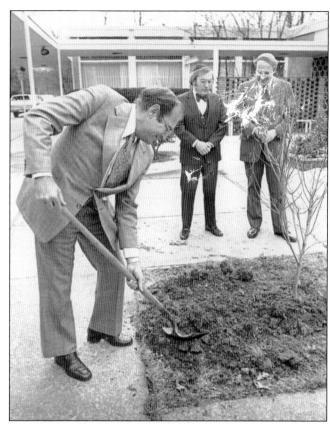

Israeli ambassador Simcha Dinitz (with shovel) plants a tree at Agudas Achim around 1975 to commemorate the ties between the American and Israeli Jewish communities. From left to right are Ambassador Dinitz, Agudas Achim president Norman Baum, and Rabbi Sheldon Elster. (Courtesy of the Capital Jewish Museum.)

Jerome and Bunny Chapman, co-presidents of Agudas Achim, observe fundraising committee chair Norman Schrott burning the deed of mortgage for the 1960s facility in this c. 1979 photograph. The deed burning is a symbolic act, but the joy is real. (Courtesy of the Capital Jewish Museum.)

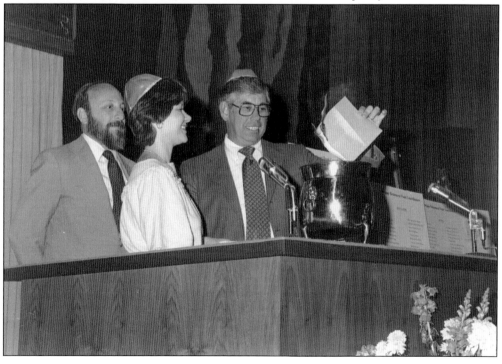

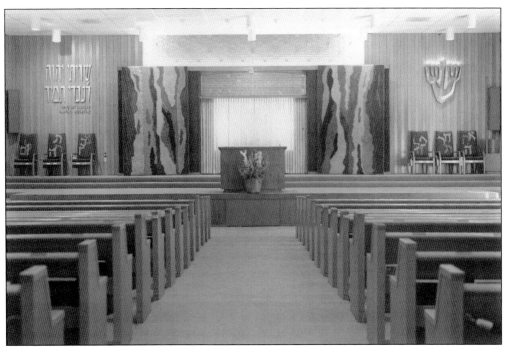

This c. 1985 photograph shows the Agudas Achim sanctuary. The English translation of the Hebrew (from Psalm 16:8) reads, "I Have Set the Lord Always Before Me." The Torah ark is behind the curtain. (Courtesy of Agudas Achim Congregation.)

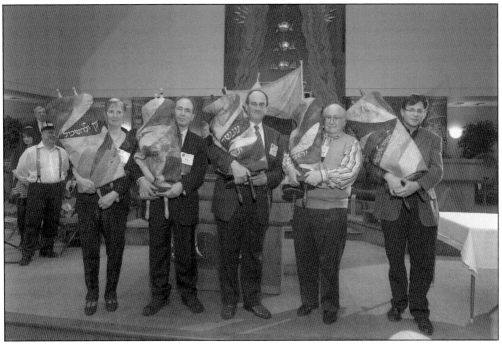

Agudas Achim members hold five of the congregation's Torah scrolls in 2010. From left to right are Randy Stein (wearing suspenders), Deborah Yaffe, Jonathan Ratner, David Yaffe, Stephen Bozen, and Cliff Braverman. (Courtesy of Agudas Achim Congregation.)

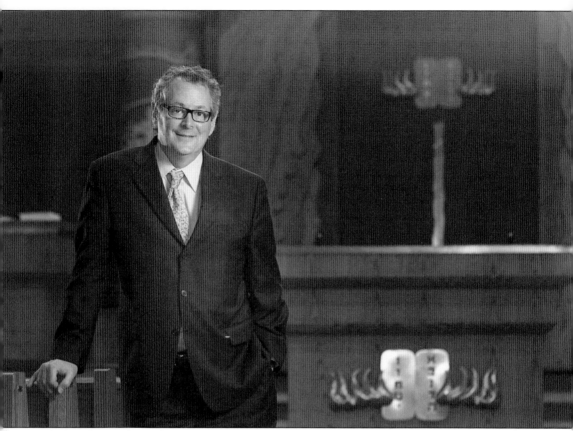

Rabbi Jack Moline, rabbi emeritus of Agudas Achim, is shown in this contemporary portrait. Rabbi Moline was the spiritual leader of Agudas Achim for almost 27 years between 1987 and 2013. (Courtesy of Agudas Achim Congregation.)

Three

COMMERCIAL AND COMMUNITY SUCCESS STORIES

JEWISH LIFE IN HERNDON, FREDERICKSBURG, WINCHESTER, AND ARLINGTON

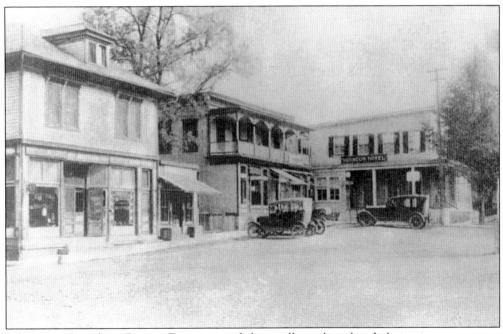

After 1880, Jews from Eastern Europe joined the small number already living in towns across Virginia since colonial times. The town of Manassas is named for a Jewish innkeeper, according to accounts from the 1860s. A few decades later, Jewish peddler Harris Levy established the all-but-forgotten town of Levy south of Gilbert's Corner. Many newcomers, like Julius Nachman, had family and commercial ties to Baltimore. Nachman moved to Herndon in 1919 and bought an interest in a dry goods store (seen here at center around 1925). Today, the building houses a coffee shop and cycling store in addition to Nachman Realty. (Courtesy J. Berkley Green Collection, Herndon Historical Society.)

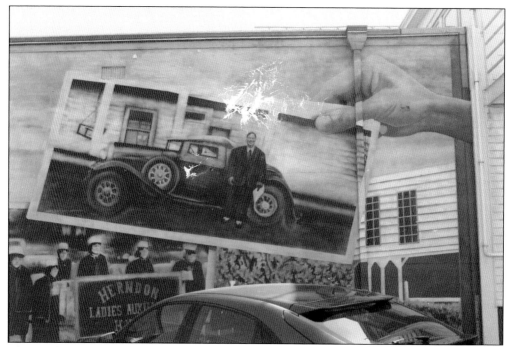

The Nachman family was always active in the community. Julius's son Melvin and grandson Howard both served on the town council—Melvin from 1954 to 1962 and Howard from 1976 to 1984. The family is widely respected and has been honored in proclamations by the State of Virginia and the Town of Herndon. This contemporary image shows a mural on the side of the Nachman Building celebrating the family's many contributions to the town. (Authors' collection.)

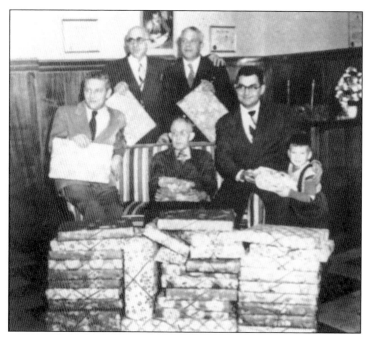

Harry Sager chartered B'nai B'rith Lodge 1679 in 1947 along with 28 other men from the Fredericksburg area. This photograph shows a charity function held by the lodge in the 1950s. From left to right are David Yanow, Harry Sager, A.L. Suskins (seated), Victor Menache, Martin Blatt, and his son Elliot Blatt. The lodge lasted 25 years before interest waned and it became inactive. (Courtesy of Ruth Friedman and Beth Sholom Temple.)

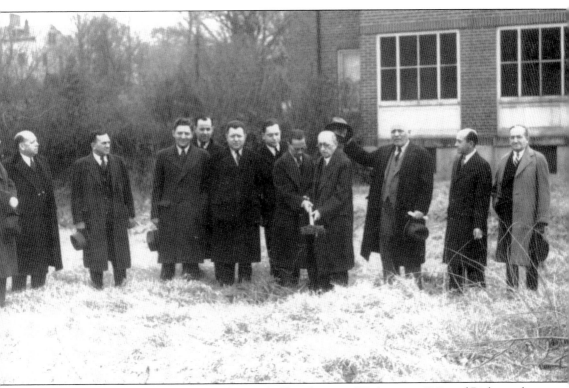

Fredericksburg is on the Rappahannock River halfway between Washington, DC, and Richmond. Nineteenth-century German Jews in Fredericksburg included the families of Isaac Iseman, Kaufman Hirsh, and Benjamin Goldsmith, who worked selling dry goods and retail clothing. They were among 12 locals who established a Hebrew Aid Society in 1880. The Jewish community grew in the first two decades of the 1900s with the arrival of Eastern European immigrants. In 1934, planning started for a synagogue, and the first services were held two years later. The ground-breaking ceremony for Beth Sholom Temple is shown in this March 5, 1940, photograph. From left to right are Joseph Goldsmith, Sydney Kaufman, Reuben Miller, David Yanow, Irvin Gallant, Mitchell Gallant, Rabbi Ulrich Steuer, Simon Hirsh, David Hirsh (holding shovel), Maurice Gallant, Karl Ulman, and Joe Ulman. (Courtesy of Beth Sholom Temple.)

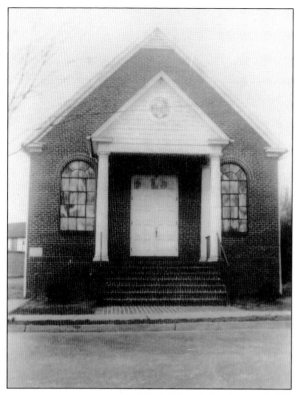

Maurice Gallant donated the land at 515 Charlotte Street for Beth Sholom. The Elks Lodge donated the ark to hold the Torahs, and congregants donated the pews. The congregation had no debt when the synagogue was dedicated on September 8, 1940. The building, shown below in 1940 and at left on a c. 1945 postcard, was designed to fit in with other buildings in the area. The windows resemble biblical tablets, and the circular window design above the doorway features a Magan David. The building itself resembles a Southern one-room schoolhouse or small church, and it currently is used as the latter. (Left, courtesy of the William A. Rosenthall Collection, Addlestone Library, College of Charleston; below, courtesy of Beth Sholom Temple.)

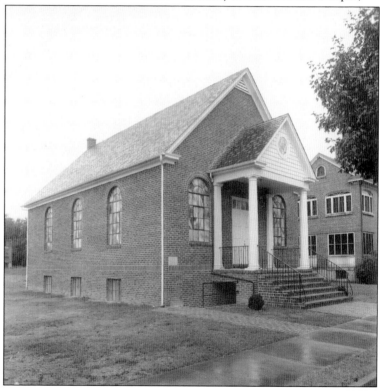

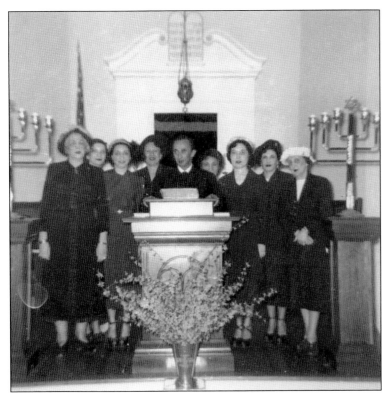

The Beth Sholom Sisterhood is leading Shabbat religious services in this 1951 photograph. From left to right are Hattie Kaufman, Norma Morganstern, Miriam Miller, Teressa Liteman, Rabbi Leon Elsberg, Hannah Ulman Stevens, Sarah Lee Margolis, Hortense Hirsch, and Ida Hirsh. (Courtesy of Beth Sholom Temple.)

Rabbi Isidore Franzblau served as rabbi of Beth Sholom Temple from 1954 to 1971. His wife, Rebbetzin Reba Cohn Franzblau, also played a central role in the congregation. Rabbi Franzblau (shown here in about 1970) and the Rebbetzin were honored with commemorative portraits that still decorate Beth Sholom today. (Courtesy of Ruth Friedman and Beth Sholom Temple.)

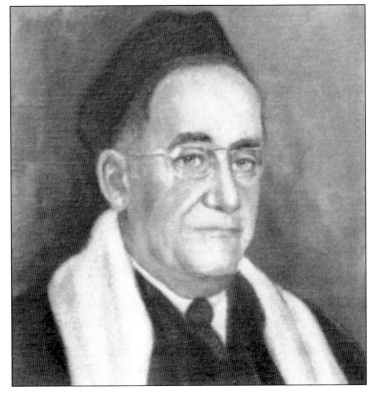

41

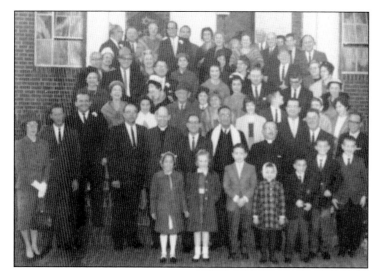

The congregants of Beth Sholom Temple celebrated its 25th anniversary on December 3, 1961. This photograph shows congregants at the temple rededication ceremony. (Courtesy Ruth Friedman and Beth Sholom Temple.)

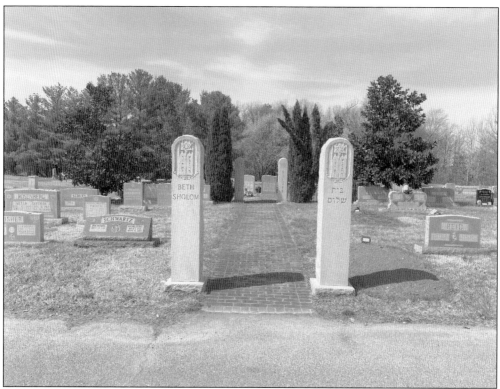

In 1957, Beth Sholom purchased an area within Oak Hill Cemetery in Fredericksburg to use for Jewish burials. Many longtime members of Beth Sholom, including Rabbi and Rebbetzin Franzblau and community benefactors Carl and Maxine L. Silver, are buried here. Before the Oak Hill purchase, many members of Beth Sholom were buried at the Baltimore Hebrew Cemetery. (Authors' collection.)

After 61 years on Charlotte Street in Fredericksburg, Beth Sholom moved to a much larger home in 2001 at 805 Lyons Boulevard in Stafford. This contemporary photograph shows the new building. Stafford has grown dramatically in recent decades, and many residents of the area commute to jobs throughout Northern Virginia and Washington, DC. (Authors' collection.)

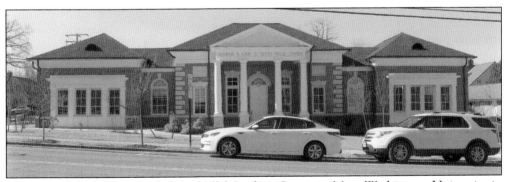

Maxine and Carl Silver funded the Hillel Student Center at Mary Washington University in Fredericksburg to support the growing number of Jewish students there. This contemporary photograph shows the spacious, modern Hillel Student Center located near the heart of the university. Carl Silver and Maxine Lyons were married in Beth Sholom Temple in Fredericksburg on November 6, 1949. After starting in business with one car dealership, Carl became a real estate developer. Over his career, he developed more land within and around Fredericksburg than any other individual. His largest project is Central Park, a complex at the intersection of Routes 3 and 95. (Authors' collection.)

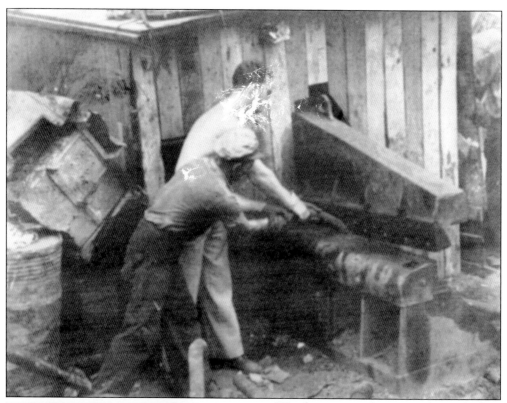

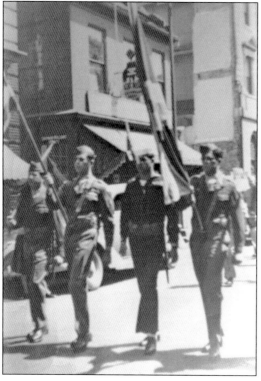

Winchester is in the scenic Shenandoah Valley 75 miles west of Washington, DC, and 100 miles from Baltimore. The town has always been a crossroads and today no fewer than five major highways pass through it. About 19 Jews lived there in 1878, mostly Orthodox German Jewish merchants and their families with ties to Baltimore. New arrivals from Eastern Europe tripled the size of the community to 57 by 1937. Louis Zuckerman moved his family to Winchester in 1917 and started a scrap business. His son Joe Zuckerman (with white gloves) and an unidentified man are working in the Cameron Street scrap yard around 1930. (Courtesy of Stewart Bell Jr. Archives, Handley Regional Library.)

All of Louis Zuckerman's sons served in the military during World War II. Shown here in the 1946 Memorial Day Parade are, from left to right, Charles M., Aaron M. Joseph, and Samuel Zuckerman. Not shown is their brother Irvin. (Courtesy of Stewart Bell Jr. Archives, Handley Regional Library.)

Max Novick moved to Winchester in 1908. This 1918 photograph shows his son Abe Novick at the wheel of Max's 1918 Federal truck used in Max's scrap metal business. The Novicks owned the third truck in Winchester, and Abe used it to found the highly successful Novick Transfer Company. (Courtesy of Stewart Bell Jr. Archives, Handley Regional Library.)

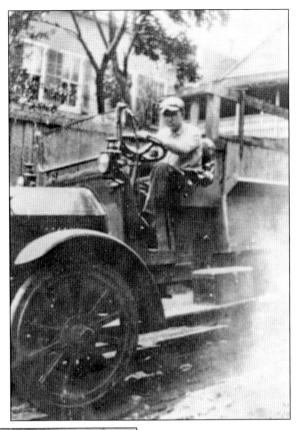

Officials of the Novick Transfer Company Inc. pose on the steps of the George Washington Hotel in Winchester in 1939. Some of the men present (in alphabetical order) are Charles Anderson, Ben Belchic, Lawrence T. Fauver, Joe Hershberger, Abram J. "Abe" Novick, and George Snider. (Courtesy of Stewart Bell Jr. Archives, Handley Regional Library.)

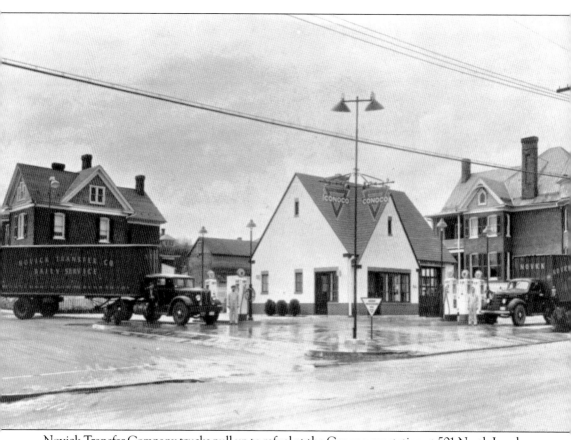

Novick Transfer Company trucks pull up to refuel at the Conoco gas station at 501 North Loudoun Street in this c. 1940s image. The Novicks have been leaders and supporters of the community for generations. (Courtesy of Stewart Bell Jr. Archives, Handley Regional Library.)

Winchester's early Jewish community had many Orthodox members, and Abe Novick provided trucks to deliver kosher food from Baltimore. In 1908, a small group organized the first religious services. Philip Klompus and Philip Kramer were early spiritual leaders of the community. They organized the first High Holy Day religious services at the home of Max Moses in 1910 with the assistance of visiting clergy from Baltimore. Kramer is shown here around 1908–1909. (Courtesy of Stewart Bell Jr. Archives, Handley Regional Library.)

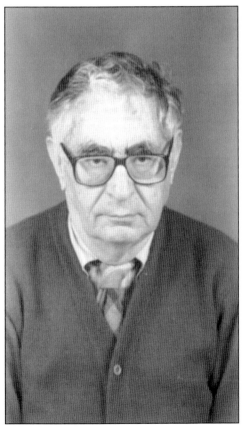

Orthodox practice waned over the first three decades of the 1900s, and Reform became the prevalent Jewish practice in Winchester. In 1932, a Men's Club formed, and in 1950, religious school classes commenced. A core group formed to create Beth El Congregation including Betty and Seymour Barr, Virginia and Charles Zuckerman, Ben Belchic, Jack Bloom, Abe Cooper, Myer Hamburger, Abe Leven, Nathan Platt, Eleanor Rappaport, and Jack Stern. Seymour J. Barr (1917–2003) is shown here around 1990. (Courtesy of Stewart Bell Jr. Archives, Handley Regional Library.)

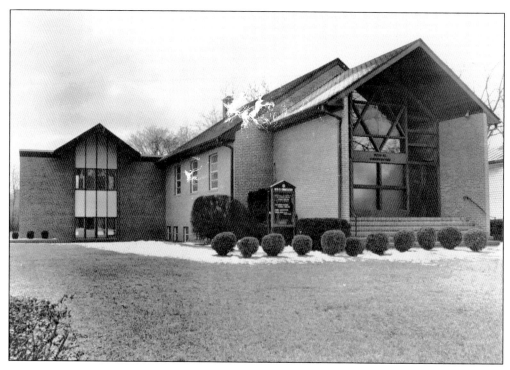

The ground breaking for a new synagogue took place in 1954, overseen by Seymour Barr. Construction was completed and the building was dedicated on March 11, 1956. Five years later, in 1961, the Novick family donated a two-story wing for the growing religious school. This pair of photographs shows the newly constructed Beth El Congregation at 528 Fairmont Avenue, Winchester, around 1960 (above) and today (below). (Both, courtesy of the Stewart Bell Jr. Archives, Handley Regional Library.)

Ben Belchic (1908–1977) was another leader of the Jewish community and was involved in an extraordinary range of local area communal activities, including serving as the longtime president of the Winchester–Frederick County Historical Society. Belchic (center, portraying Benjamin Franklin) is seen here at the Winchester Bicentennial Ball with (later mayor) William M. Battaile and his wife, Virginia, on February 22, 1952. (Courtesy of Stewart Bell Jr. Archives, Handley Regional Library.)

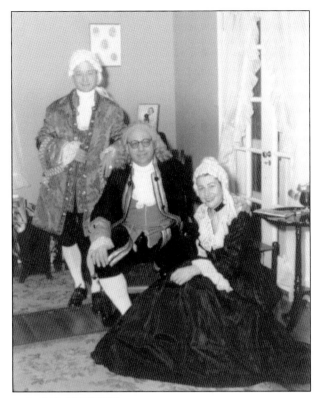

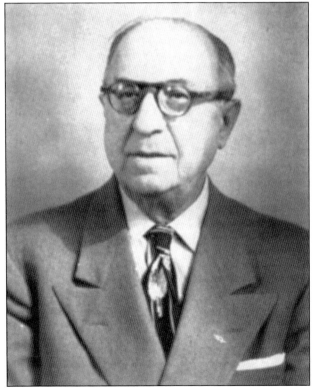

Jack I. Bloom was a key leader of the community. He served as the first president of Beth El Congregation when the temple was dedicated. This photograph is from the late 1950s. (Courtesy of Stewart Bell Jr. Archives, Handley Regional Library.)

In 1957, Beth El Congregation acquired a section in Shenandoah Memorial Park cemetery. Prior to this, Jewish burials were conducted in Baltimore or Martinsburg, West Virginia, about 20 miles away. The remains of Seymour Barr and other prominent members of Beth El are interned there. (Courtesy of Beth El Congregation.)

This c. 1970 photograph shows the interior of Beth El Congregation's sanctuary. In 2019, the congregation celebrated its 65th anniversary with a mix of new and old members and three past and present rabbis in attendance. There are currently about 100 Jewish families in the Winchester area and the town is growing rapidly. (Courtesy of Stewart Bell Jr. Archives, Handley Regional Library.)

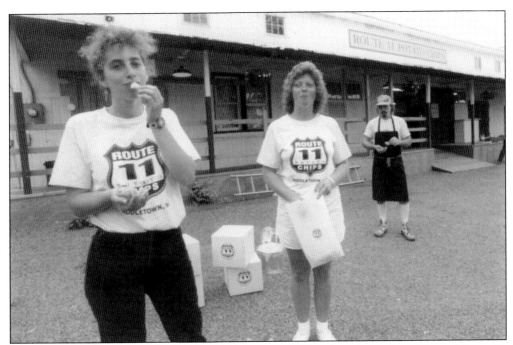

Sarah Cohen (left) moved to the Winchester area in 1992 as founder and president of Route 11 Potato Chips. The company makes small batches of specialized chips that are shipped around the country. It includes a large factory store in Mt. Jackson, Virginia, employing 42 locals, and in 2021, the company began exporting chips to Israel. Cohen said, "If someone told me at 18 that I would be making potato chips and living in the Shenandoah Valley, I would have thought they were crazy." Thirty years later, she loves the lifestyle that Winchester offers. "It was accidental, but I found my calling." (Courtesy of Sarah Cohen.)

The current generation of Jewish arrivals in the Winchester area includes Beth El member John Netzel, who arrived in 2012 and started the 13-acre Peaceful Fields Animal Sanctuary. (Courtesy of John Netzel)

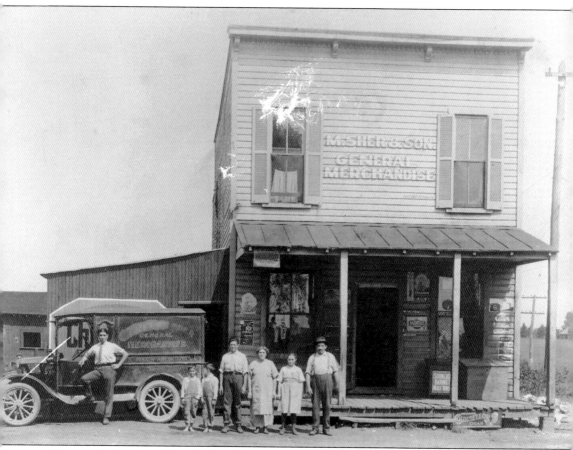

Arlington is less than 10 miles from Alexandria, but Jewish life was very different in the two towns in the first half of the 1900s. In 1918, Menasha and Esther Sher purchased this general store at the corner of Walter Reed Drive and Columbia Pike, where the Arlington Cinema and Drafthouse now stands. The Shers had five children, four boys and a daughter named Ida. They were one of the few Jewish families in the area. Ida married Sol Cohen, and the two took over the general store when Menasha Sher became too ill and infirm to continue working in the late 1920s. This c. 1922 photograph shows the Sher general store and the family with their Model T. (Courtesy of Ruth Levin and the Center for Local History, Arlington Public Library.)

This 1925 photograph shows Joe Sher (1915–1991) on the left with his twin brother, Hyme Sher (1915–1967), standing behind the Sher general store in Arlington. The boys went on to attend Washington and Lee High School in Arlington and were in the school's second or third graduating class. (Courtesy of Ruth Levin and the Center for Local History, Arlington Public Library.)

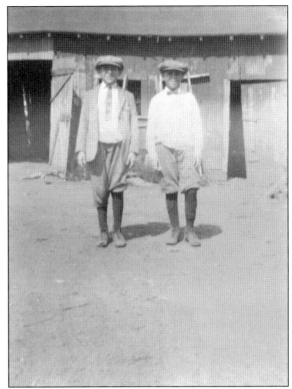

The women in this c. 1935 photograph were participating in an Introduction to Birdseye Frozen Foods event sponsored by the Cohen store. Behind them, several women appear to be preparing food for the demonstration.

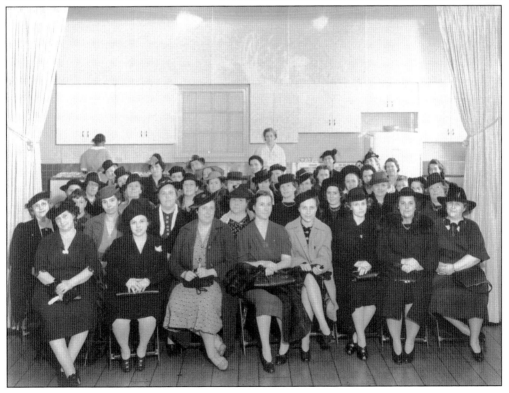

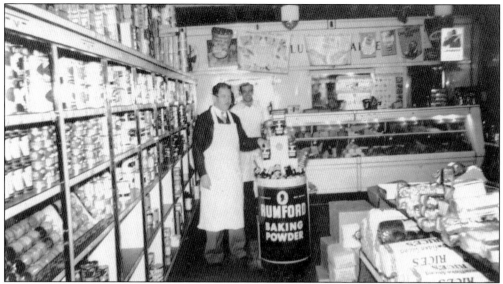

Sol Cohen and Abe Sher are seen here working inside the store around 1935. Cohen closed the store during World War II. (Courtesy Ruth Levin and the Center for Local History, Arlington Public Library.)

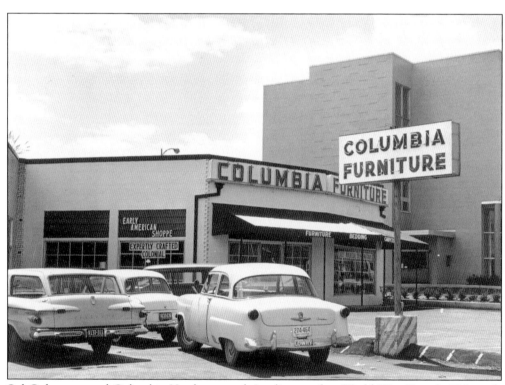

Sol Cohen opened Columbia Hardware and Appliance after World War II, only 200 yards away from where Sher's general store once stood. This picture was taken in 1962 after the store changed its name to Columbia Furniture. (Courtesy Ruth Levin and the Center for Local History, Arlington Public Library.)

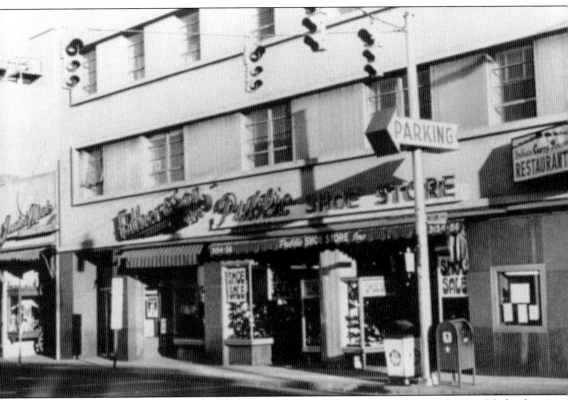

In 1940, Arlington residents Sam Friedman, Herman Schwartzman, Harry Austin, Michael Hornick, and Frank Kahn met to form the congregation Ohev Shalom. In 1942, the congregation held High Holy Day services above Sam Friedman's Public Shoe Store at 3154 Wilson Boulevard, known as the Jones Building (pictured). Friedman started the business in 1938, and his son Sholom "Doc" Friedman, a podiatrist, worked in the business for 75 years. The store moved to 3137 Wilson Boulevard in the 1970s as preparations advanced to build the Clarendon Metro station on the original location. The business closed in 2016, and Doc Friedman passed away in 2019. (Courtesy Ruth Levin and the Center for Local History, Arlington Public Library.)

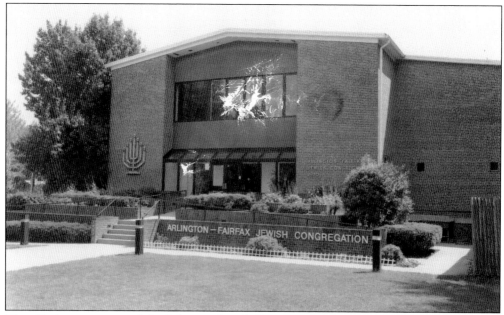

Ohev Shalom was renamed the Arlington Jewish Center, and in 1944, the congregation purchased land for a synagogue. The ground-breaking ceremony was held in 1947, and the current building at 2920 Arlington Boulevard was dedicated a year later. A second floor was added in 1955. The congregation was renamed again to become the Arlington-Fairfax Jewish Congregation. The building is shown here in 1996. (Courtesy of the Center for Local History, Arlington Public Library.)

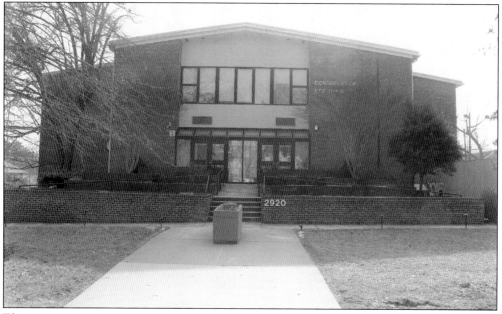

The congregation was at a crossroads between Alexandria's established community and the rapidly growing Fairfax County. Jewish life there was exceptionally active from the late 1940s through the 1960s. Organizations like the Jewish War Veterans, Jewish National Fund, Hadassah, B'nai B'rith, ORT, and others had meetings at the synagogue. The congregation changed names yet again in 2003 to Etz Hayim (Tree of Life). This photograph shows the synagogue today. (Authors' collection.)

Ar-Fax was a hub of activity led by a cadre of committed and motivated leaders. Shown here are Beatrice Fleishman, Hebrew school teacher Rachel Reinitz, longtime Hadassah and Jewish Community Relations Council leader Joan Sacarob, Ar-Fax Sisterhood president Zelda Dick, Seaboard Regional president Riva Kramer, and Lillian Lutzin. (Courtesy of Joan and Don Sacarob.)

The children in this 1954 photograph are learning about the Jewish harvest holidays at the Arlington-Fairfax Jewish Center. (Courtesy of Congregation Etz Hayim.)

Joseph Mayerowitz is shown in this c. 1975 photograph behind a display created for Sukkot. For many years, Mayerowitz led the minyan prayer services at Arlington Fairfax Jewish Congregation. (Courtesy of Congregation Etz Hayim.)

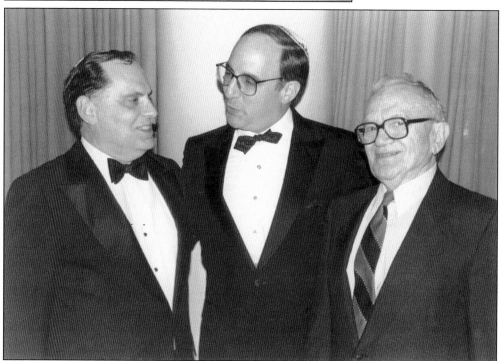

The 50th anniversary of Arlington-Fairfax Jewish Congregation in 1990 brought together Rabbi Marvin Bash (left), Rabbi Noah Golinkin (center), and congregant Jerry Jacobs (right). (Courtesy of Congregation Etz Hayim.)

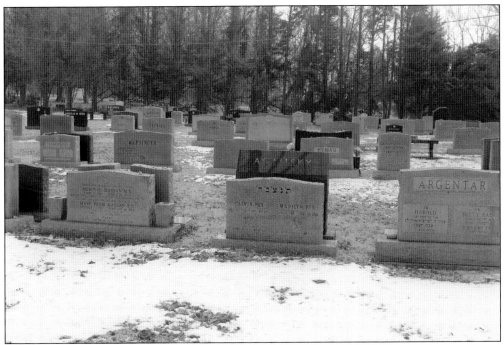

The largest Jewish cemetery in the region opened in Falls Church in the late 1950s. King David Memorial Gardens includes sections with flat markers and standing headstones, as seen in this contemporary photograph. Some notable burials include columnist William Safire; former senator Richard Stone; Isaiah L. "Si" Kenen, founder of the American Israel Public Action Committee; Abe Pollin, owner of the Washington Wizards basketball team; NBA coach Red Auerbach; and author Warren Adler. The cemetery also has a genizah, a place for the burial of worn-out religious texts. Hebrew works that contain references to God are respectfully buried rather than carelessly discarded. (Authors' collection.)

Arlington is home to Arlington National Cemetery, where Jewish military and national figures have been buried for over 150 years. Researchers from the Jewish Genealogical Society of Greater Washington have identified over 5,000 Jewish burials in the cemetery. One of many distinguished Jewish memorials is dedicated to Jewish chaplains who made the ultimate sacrifice in service to the country. Former Supreme Court justice Ruth Bader Ginsburg (1933–2020) is buried nearby. (Courtesy of Arlington National Cemetery.)

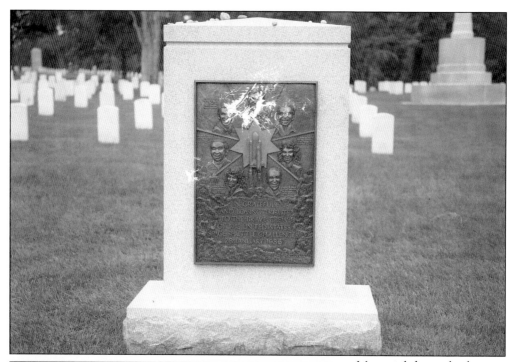

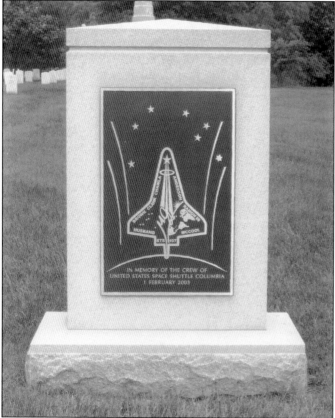

Memorials have also been dedicated to the crews of the space shuttles *Challenger* and *Columbia*. American Jewish astronaut Judith Arlene Resnick (1949–1986) and Israeli astronaut Ilan Ramon flew on these ill-fated spacecraft. Each star in the *Columbia* memorial commemorates an astronaut; note the six-pointed star on the right for Ramon. (Both, courtesy of Arlington National Cemetery.)

Four

RAPID GROWTH, A NEW GENERATION, AND NEW FRONTIERS

FALLS CHURCH AND FAIRFAX

The post–World War II years saw rapid growth in Northern Virginia, and Jews participated in small and large ways helping to shape the region. Many were also philanthropists who provided major support to community projects across the area. This 2006 photograph shows Crystal City, developed by Charles E. Smith along with his son Steve Smith and son-in-law Robert Kogod starting in 1963. Other real estate projects include Tysons Corner (the Gudelsky family, Theodore N. Lerner, and Max Ammerman), Reston (Robert E. Simon), Shirlington (Joseph Cherner), Central Park in Fredericksburg (Carl Silver), and others. (Courtesy of the Town of Arlington.)

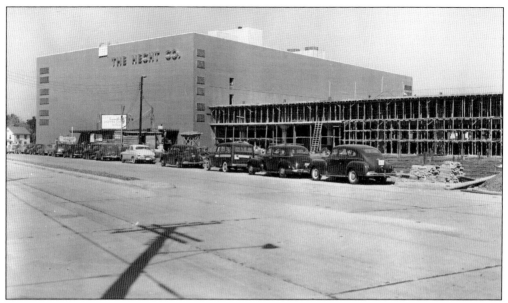

Some small Jewish-owned corner markets and clothing and general stores grew into major chains and department stores in the area. The Hecht Company was founded in Baltimore by the German Jewish immigrant Sam Hecht in 1859. This photograph shows a Hecht Company store under construction in Ballston (then called Parkington) in 1951. Kann's clothing store, founded in Washington by Louis, Solomon, and Sigmund Kann in 1893, opened nearby the same year. Samuel Lehrman and Nehemiah Cohen founded the first Giant Food Store in the 1950s. The company grew into a chain with more than 50 stores and remained in family hands until 1998. Competitors Irving and Kenneth Herman and brother-in-law Samuel Levin opened Shoppers Food Warehouse in 1979. (Courtesy of the Center for Local History, Arlington Public Library.)

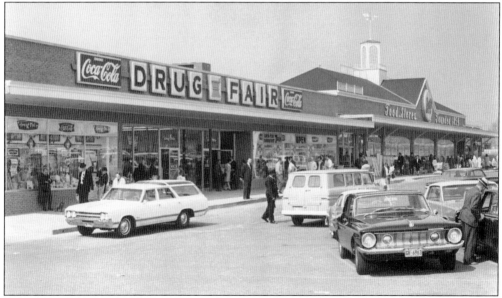

Milton Elsberg opened a pharmacy in Arlington with Robert Gerber in 1958. By the late 1970s, Drug Fair had expanded into a regional chain of 176 stores. (Courtesy of Stuart Elsberg, Capital Jewish Museum.)

Harry Rosenthal (with shovel on left) and his son Bob (on right) broke ground for Rosenthal Chevrolet at the intersection of Glebe Road and Columbia Pike in Arlington in 1954. This was one of several dealerships in Northern Virginia owned by area Jews. (Courtesy of Robert Rosenthal, Captial Jewish Museum.)

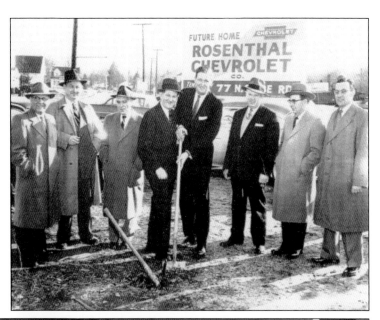

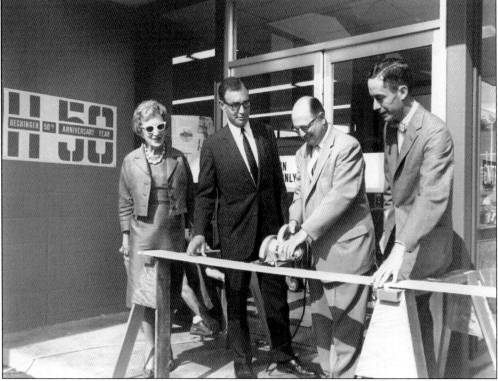

Hechinger's was the Washington region's iconic hardware and garden store. Sydney L. Hechinger founded the company in 1911, and it grew to 131 stores before closing in 1999. This photograph shows a ceremony at the Alexandria store with company president John Hechinger (second from left, next to his mother, Sylvia), manager Leroy Bendheim, and Hechinger chairman Richard England (on right). Bendheim later became mayor of Alexandria and president of Beth El Hebrew Congregation. (Courtesy of Hechinger Company Records, DC History Center [CHS 12678.02].)

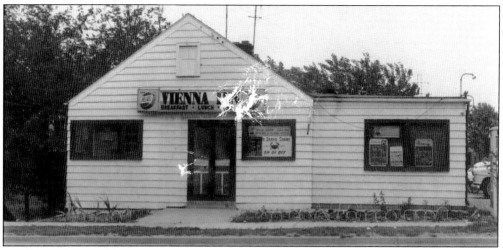

Small Jewish-owned businesses across Northern Virginia have been part of the fabric of local life for over 175 years. Meyer H. "Mike" Abraham and his wife, Molly, bought a business called Freddy's Café in 1960. They renamed it the Vienna Inn, and it quickly became a local landmark known for its unrefined charm and chili dogs. Their son Philip joined the business in 1984. He said, "What makes the pub special is its patrons. A lot of these guys were at my bar mitzvah." The photograph shows the Vienna Inn in 1965. The Abrahams sold the inn in 2000, and it remains an icon. (Courtesy of the Fairfax County Public Library Photographic Archive.)

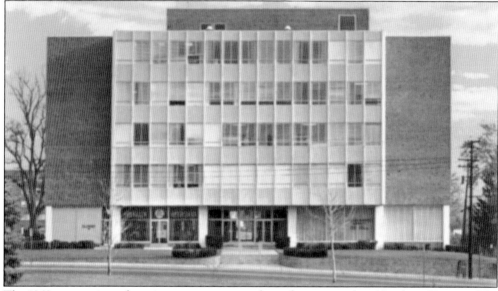

The 1960s were a time of continuous economic and population growth in Northern Virginia. The wave of Jewish families moving to Falls Church and Fairfax County came from Alexandria and Arlington and from across America. The established Alexandria and Arlington congregations could no longer fully meet the needs of all the new families. In late June 1962, thirty-six families —mostly from Temple Beth El in Alexandria—met in the community room of the Fink Building at 200 Little Falls Road, Falls Church (shown in this postcard from the period) and agreed to constitute a new Reform congregation. Herman Fink was a founding member of the congregation, which was called Rodef Shalom. Soon, more families in the area joined. (Courtesy of the Local History Collection, Mary Riley Styles Public Library.)

Religious services were conducted in the summer of 1962 by a series of guest rabbis. Rabbi David Martin Zielonka, a recent graduate of Hebrew Union College, led the first High Holy Day services for the congregation in late September of that year. (Courtesy of the Temple Rodef Shalom Archive.)

Rodef Shalom set up a religious school by August 1962. Seen here is the first consecration class photograph taken on October 19 of that year, only four months after the congregation organized. (Courtesy of the Temple Rodef Shalom Archive.)

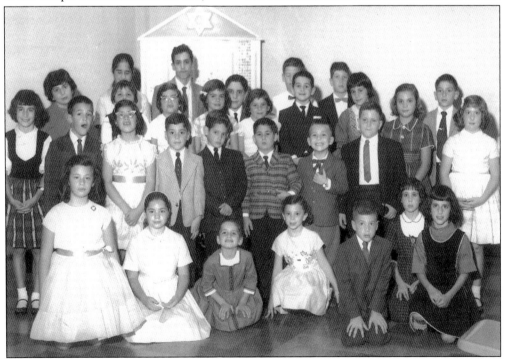

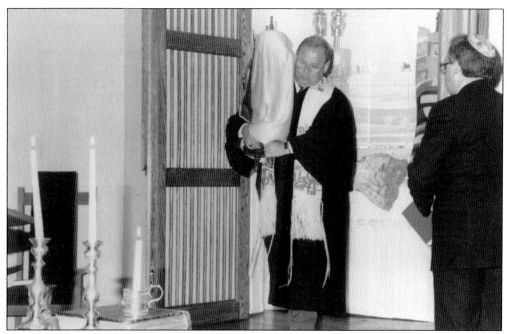

The temple hired 34-year-old Lazlo Berkowits on a one-year contract starting in July 1963. Berkowits was ordained one month later. He retired as a full-time rabbi 35 years later in 1998 and served as rabbi emeritus at Rodef Shalom until his death in 2020 at age 92. Berkowits (seen here around 1985) was a Holocaust survivor who was rescued from a Nazi concentration camp at Auschwitz in 1945. (Courtesy of the Temple Rodef Shalom Archive.)

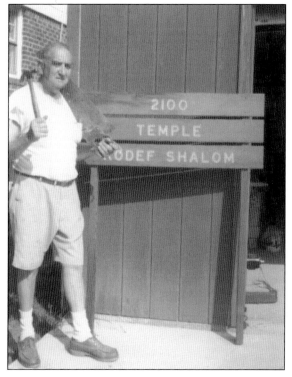

Ten Rodef Shalom members purchased a seven-acre lot on Westmoreland Street in 1963. The land was dedicated in June 1965, and the building's cornerstone was dedicated in November 1969. The building was ready for High Holy Day services in 1970. In this undated photograph, congregant Mike Perlin prepares the sign announcing Temple Rodef Shalom at 2100 Westmoreland Street. (Courtesy of the Temple Rodef Shalom Archive.)

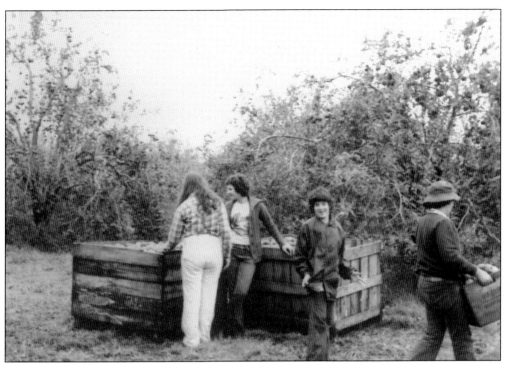

Temple Rodef Shalom has a full range of activities for young members including the Reform Movement's National Federation of Temple Youth Group (NIFTY). One popular activity was an apple-picking outing, seen in this c. 1978 photograph. (Courtesy of the Temple Rodef Shalom Archive.)

Rodef Shalom was one of the synagogues to host the Achva Jewish summer camp in the 1970s. By 1976, the temple had grown large enough to support a camp of its own. A class of Rodef Shalom campers is shown here around 1980. (Courtesy of the Temple Rodef Shalom Archive.)

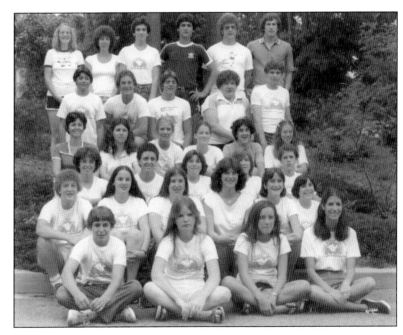

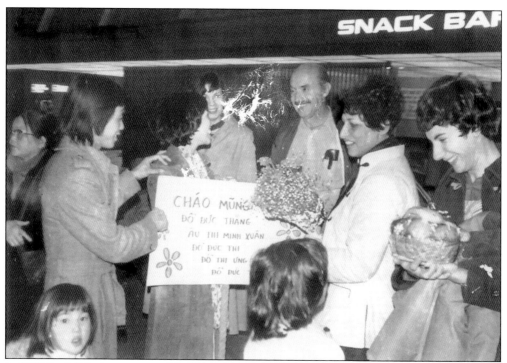

In 1979, Rodef Shalom sponsored five Vietnamese families who escaped after the collapse of South Vietnam, including the Do family. The congregation donated clothing, appliances, furniture, and assistance with housing, job searches, language training, medical needs, and acculturation issues. The family is seen here being warmly welcomed by congregants. The temple has subsequently hosted other families from the former Soviet Union and Eastern Europe. (Courtesy of the Temple Rodef Shalom Archive.)

The temple has been enlarged and renovated several times to accommodate the growth and changing needs of congregants. This undated photograph shows the building after the first major renovation. (Courtesy of the Temple Rodef Shalom Archive.)

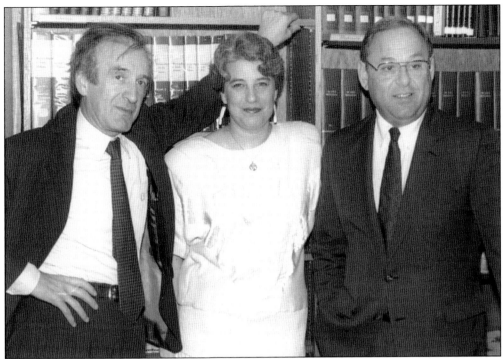

In 1987, Rodef Shalom had grown to 628 families and celebrated its 25th anniversary. Nobel Laureate Elie Wiesel (left) spoke to a Rodef Shalom audience of over 1,200 on November 1 of that year. Wiesel and Rabbi Berkowits (right) shared firsthand accounts of their experiences during and after the Holocaust. At center is congregant Robbie Cohrssen. (Courtesy of the Temple Rodef Shalom Archive.)

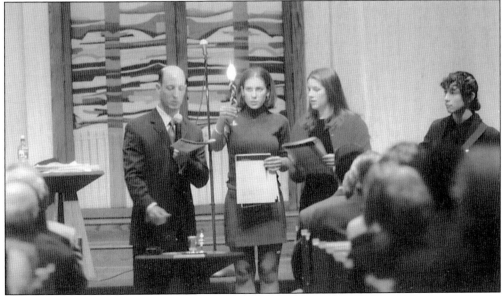

Rabbi Burstein (left) leads a Havdalah ceremony to mark the end of Shabbat. Ally Coor holds the braided Havdalah candle, while Katie Mullen and Jonathan Koslow look on. This photograph is from around 2000. (Courtesy of the Temple Rodef Shalom Archive.)

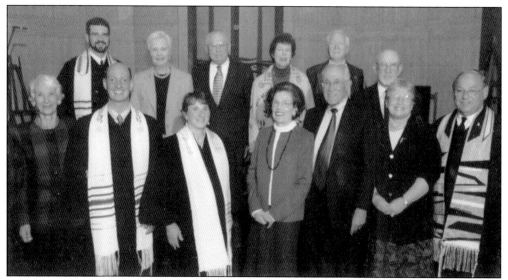

Rabbi Amy Schwartzman joined Rodef Shalom as assistant rabbi in 1990. By 1998, temple membership approached 1,000 families. Rabbi Schwartzman became senior rabbi that year when Rabbi Berkowits became emeritus. Cantor Michael Shochet also joined the temple in 1998, and Rabbi Marcus Burstein became the new assistant rabbi the following year. Rodef Shalom clergy and founding members are shown in this c. 2001 photograph. From left to right are (first row) Ida Silverstein, Rabbi Marcus Burstein, Rabbi Amy Schwartzman, Carol Davidson, Gene Davidson, Ed Proctor, Lois Proctor, and Rabbi Laslo Berkowits; (second row) Cantor Michael Shochet, Rose Thorman, Burt Thorman, Harriet Epstein, and Henry Epstein. (Courtesy of the Temple Rodef Shalom Archive.)

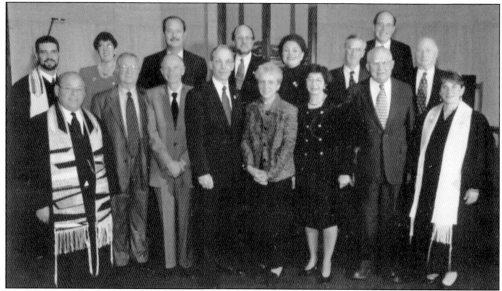

Today, Rodef Shalom is the largest synagogue in Northern Virginia and the spiritual home to over 1,600 families. The clergy and past presidents shown around 2001 are, from left to right (first row) Rabbi Laszlo Berkowits, Bill Bekenstein, Gerry Greenwald, Jonathan Kosarin, Susan Simon, Betty Nan Obermayer, Burt Thorman, and Rabbi Amy Schwartzman; (second row) Cantor Michael Shochet, Ellen Blalock, Sam Simon, Richard Friedman, Cheri Artz, Hank Seiff, Alan Frey, and Armand Weiss. (Courtesy of the Temple Rodef Shalom Archive.)

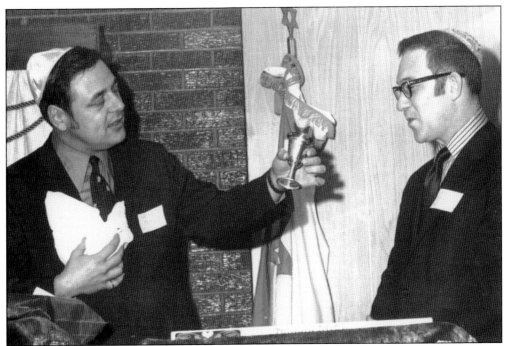

When the Capital Beltway was constructed between 1961 and 1964, it helped unite Northern Virginia with the larger metropolitan area. It also created the areas that came to be known as "inside the beltway" and "outside the beltway." By May 1964, six families from the Ar-Fax Congregation (now Etz Haim) found their carpools from Fairfax to the synagogue unmanageable. Their solution was to start the first new synagogue outside the beltway, later named Congregation Olam Tikvah. The six families were Rhonda and Ronnie Bernstein, Bev and Ron Goldberg, Mimi and Len Levine, Evie and Al Plait, Bernie and Arnie Smokler, and Gloria and Ira Seiler. This c. 1965 photograph shows Warren Kranz presenting a kiddush cup to Edward Kessler before the first permanent rabbi was hired or a building constructed. Many early services were held in nearby Annandale Elementary School. (Courtesy of Congregation Olam Tikvah.)

In May 1966, the young congregation had over 100 member families and purchased a house on three and a half acres on Glenbrook Road in Fairfax. A year later, in mid-1967, it hired the first full-time rabbi, Itzhaq M. Klirs, shown here (center) being introduced to the congregation by Olam Tikvah's past president Robert Grossman (left) and president Edward Kessler. Rabbi Klirs was raised in Mandate Palestine, fought in the 1948 War of Independence, and was working in South Africa when hired to come to Virginia. (Courtesy of Congregation Olam Tikvah.)

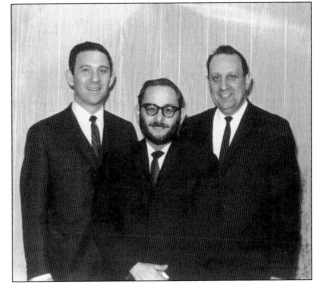

Congregation Olam Tikvah

Ground Breaking Ceremony

24 Elul 5729 - September 7, 1969

This is the announcement for the Congregation Olam Tikvah ground-breaking ceremony held on September 7, 1969. (Courtesy of Congregation Olam Tikvah.)

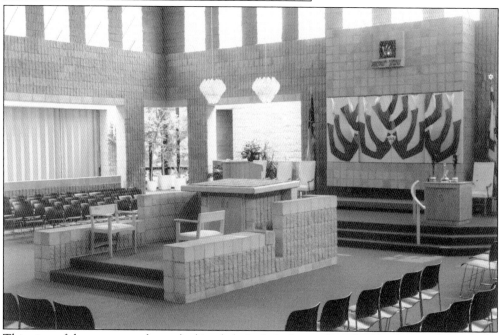

This view of the sanctuary shows the bimah (raised platform where the Torah is read) facing the ark holding the Torah scrolls. Olam Tikvah is the first synagogue in Northern Virginia to set the bimah amidst congregant seating. This design follows traditional Jewish practices dating at least to the Middle Ages, and is becoming more common in American congregations. (Courtesy of Congregation Olam Tikvah.)

Laura Fuchsman became the first to celebrate a b'nai mitzvah in the newly constructed sanctuary in 1972. Her father, Al Fuchsman, constructed the podium. Earlier, Stan Grossman was the first Olam Tikvah congregant to celebrate his bar mitzvah, though it was held in the Glenbrook house, before the sanctuary was constructed. (Courtesy of Laura Adler.)

Olam Tikvah congregants participated in a steady stream of fundraising activities to help cover the costs of the property and building. This June 16, 1973, photograph was taken at Rosecroft Raceway in Fort Washington, Maryland. The purse from one of the races was donated to support the congregation. Sheila and Lonny Felsen (far right) organized this outing and other fundraising events for the new congregation. (Courtesy of Congregation Olam Tikvah.)

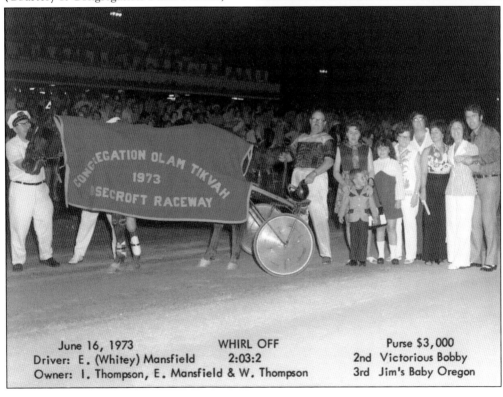

June 16, 1973	WHIRL OFF	Purse $3,000
Driver: E. (Whitey) Mansfield	2:03:2	2nd Victorious Bobby
Owner: I. Thompson, E. Mansfield & W. Thompson		3rd Jim's Baby Oregon

Olam Tikvah has always maintained a robust religious school. This 1980 photograph shows a graduating confirmation class. Rabbi Klirs stands on the right. The woman on the left is the religious school principal. (Courtesy of Congregation Olam Tikvah.)

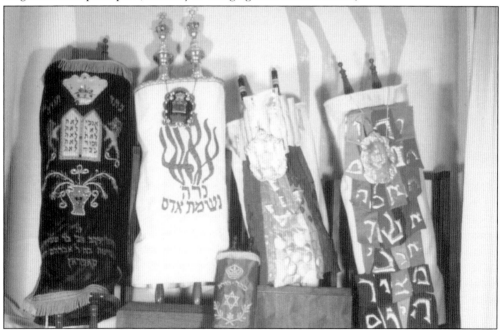

This 1977 image of the ark shows Olam Tikvah Torah scrolls. The scrolls are adorned with decorated covers featuring traditional Jewish motifs. (Courtesy of Congregation Olam Tikvah.)

Eleven presidents and past presidents of the Olam Tikvah Sisterhood posed for this extraordinary photograph. From left to right are (first row, seated) Layne Seelig, Louise Hodin, Brenda Klemow, Bev Goldberg, and Deedy Eisenson; (second row, standing) Sandy Gabriel, Cookie Gruber, Ellen Poor, Susan Bloom, Rachelle Palley, and Judy Werbel. (Courtesy of Congregation Olam Tikvah.)

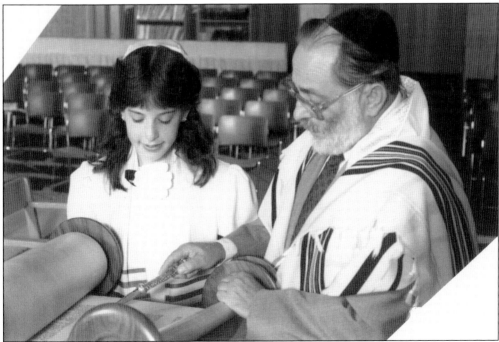

Rabbi Klirs poses with a bat mitzvah student in this 1990 photograph taken inside the sanctuary. Bar and bat mitzvah services and other life-cycle events are occasions for communal celebration. (Courtesy of Congregation Olam Tikvah.)

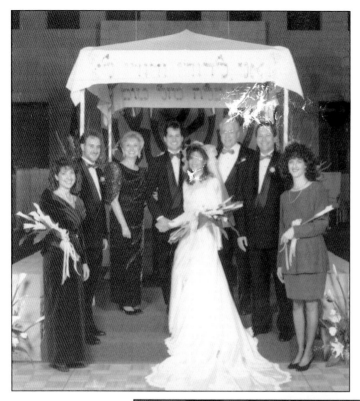

This photograph from 1991 was taken inside Congregation Olam Tikvah's sanctuary in front of a wedding chuppah. The bride is Elise Weinstein, and the groom is Michael Fuchsman. Other members of the wedding party from left to right are Laura Adler, David Adler, Dotty Fuchsman, Alvin Fuchsman, David Fuchsman, and Randi (Bettman) Fuchsman. (Courtesy of Laura Adler.)

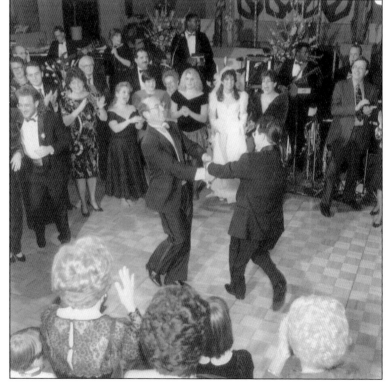

Guests at the wedding reception of Michael Fuchman and Elise Weinstein look on as Michael Hausfeld joins the groom in a joyous traditional dance at Congregation Olam Tikvah. (Courtesy of Laura Adler.)

Zenia Bielsker is seen here dressed as Queen Esther for a Purim party in 1995. Bielsker served for many years in the Olam Tikvah office and was the go-to person for countless issues. (Courtesy of Congregation Olam Tikvah.).

Olam Tikvah "Sheriff" (Rabbi David Kalender, left) and "Deputy" (Assistant Rabbi Joshua Ben-Gideon) pose in Purim costumes in front of a portrait of Rabbi Itzhaq Klirs around 2006. (Courtesy of Congregation Olam Tikvah.)

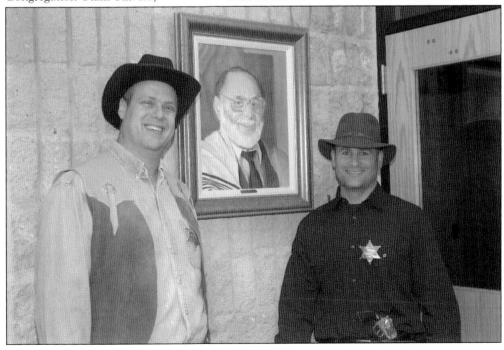

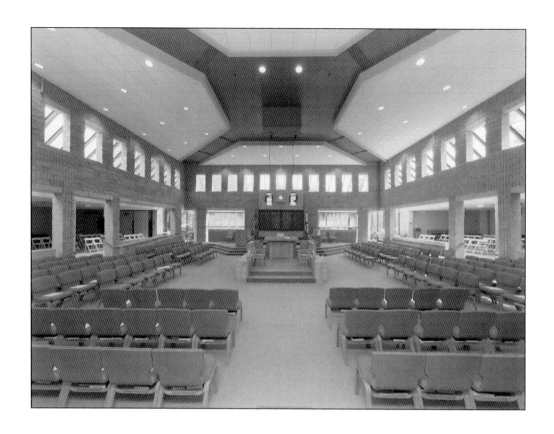

In May 2010, Olam Tikvah completed a major expansion that included a large social hall, a library, new offices, and other amenities. The photograph above shows the sanctuary in 2020 with former classroom space being used for congregation seating. The panorama of the building exterior below shows the social hall and new entrance on the right. (Both, courtesy of David Massarik.)

Five

A REGIONAL COMMUNITY EMERGES

FROM JEWISH COMMUNAL ORGANIZATIONS TO A COMMUNITY CENTER

Jews in Northern Virginia have participated in fraternal, social, and philanthropic organizations since at least 1876, when the B'nai B'rith Mount Vernon Lodge No. 259 was chartered in Alexandria. Membership has waned in recent decades, but the region has supported at least five other lodges over time. This photograph shows Steve Newman (of blessed memory) and his wife, Barbara Brenman, recruiting new members to the Fairfax Uriah P. Levy Lodge No. 2392 in 2010. Other lodges have included the Maurice D. Rosenberg Lodge No. 1555 in Alexandria, the Benjamin N. Cardozo Lodge in Arlington, Lodge No. 1679 in Fredericksburg, and a lodge in Winchester. (Courtesy of David Massarik.)

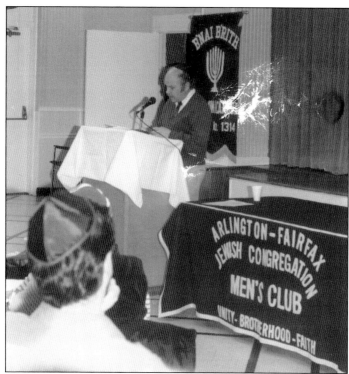

Ira Bartfield leads a joint meeting of the Arlington-Fairfax Congregation Men's Club and B'nai B'rith Benjamin Cardozo Lodge in this c. 1980 photograph. The lodge was formed in 1938 at the Arlington Jewish Center (later Ar-Fax Congregation and now Etz Hayim). B'nai B'rith was founded in New York in 1843 and remains the oldest Jewish service organization in the country. (Courtesy of Congregation Etz Hayim.)

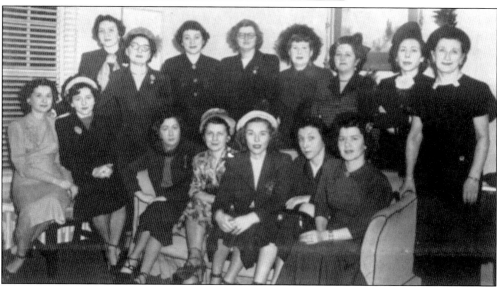

Many Jewish organizations were primarily philanthropic and based on the needs driven by world events. Examples include the Organization for Rehabilitation through Training (ORT) in 1880, the Hebrew Immigrant Aid Society in 1881, the Jewish National Fund in 1901, the Joint Distribution Committee in 1914, and the United Jewish Appeal in 1939. Several ORT chapters were formed to raise funds in Northern Virginia. This April 1949 photograph shows the Washington ORT region's 11th annual luncheon; from left to right are (first row, seated) S. Zarkin, S. Lipkowitz, K. Manchester, J. Katzman, S. Gendleman, B. Parsons, and L. Crowell; (second row, standing) A. Musher, M. Cohen, B. Heller, I. Adler, B. Bass, S. Lustig, A. Cohen, and A. Tish. (Courtesy of ORT.)

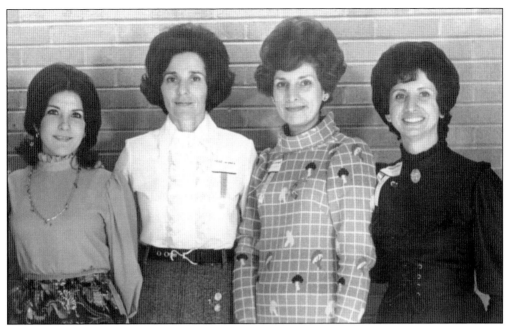

Hadassah was formed in 1912 to improve healthcare in Israel, and since late 1946 has been one of the most continually active organizations in Northern Virginia. Hadassah had an Alexandria chapter and an Arlington-Fairfax chapter until 1961, when they merged to form the Northern Virginia chapter. Today, the Northern Virginia chapter has over 900 members. Officers of the Northern Virginia chapter of Hadassah are shown in 1971. From left to right are Suzanne Price, Adele Greenspon, Bobbie Ebert, and Dotty Fuchsman. (Courtesy of Laura Adler.)

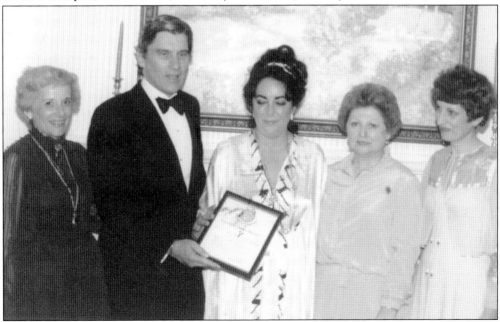

Actress Elizabeth Taylor and Congressman Mark Warner were featured guests at this Hadassah charity art auction. From left to right are Joan Sacarob, Warner, Taylor, Ester Michelle, and Bobbie Ebert. (Courtesy of Joan and Don Sacarob.)

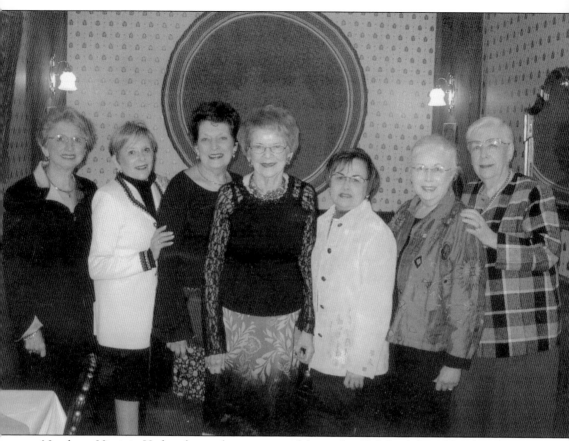

Northern Virginia Hadassah members met to celebrate the 90th birthday of Bertha Shostack (center) in 2004. Pictured with her from left to right are Dottie Fuchsman, Joan Sacarob, Bobbie Ebert, Rhoda Sulak, Jaqui Rubenstein, and Ann Mazor. (Courtesy of Joan and Don Sacarob.)

Jewish life in Northern Virginia has been enhanced and strengthened for over 50 years by community-wide summer day camps. The first effort to establish a Jewish camp experience was organized by the Northern Virginia chapter of Hadassah during the summers of 1965 and 1966 at Burke Lake Park. In 1968, Adele Greenspon (right) and Shirley Waxman, parents of camp-age children, saw a need for a day camp in the area that could nurture Jewish heritage and took the next steps to form Camp Achva. (Courtesy of Pozez JCC of Northern Virginia.)

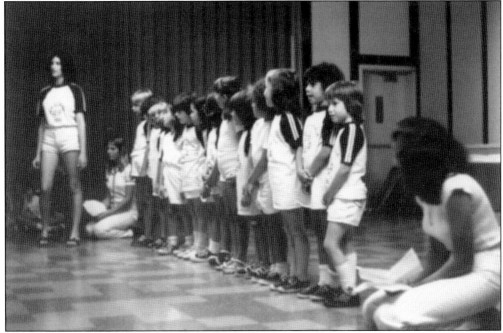

Camp Achva opened in June 1969 and is an example of the Jewish cultural renaissance that swept America after the 1967 Six-Day War. The camp was initially supported by Agudas Achim Congregation, Arlington-Fairfax Jewish Congregation, and Congregation Olam Tikvah, and later by Temple Rodef Shalom and others. The Jewish Community Center of Northern Virginia has hosted and supported Camp Achva since its earliest days. This 1976 photograph shows camp counselors preparing young campers for a skit. (Courtesy of Pozez JCC of Northern Virginia.)

Camp Achva was a strong success from the start, growing to more than a hundred campers and staff by the second year and over 150 two years later. Activities included handcrafts, music, Israeli folk dancing, art, Jewish history, and sports. Campers were also exposed to some Hebrew and a smattering of Bible background. Campers in this 1982 photograph are demonstrating an Israeli folk dance. (Courtesy of Pozez JCC of Northern Virginia.)

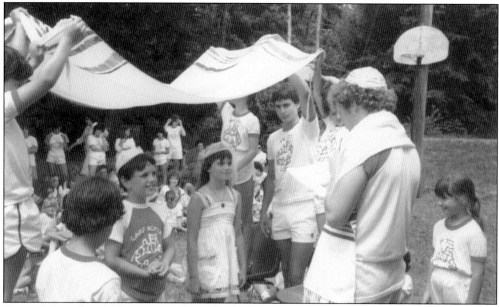

Camp Achva played a formative role in the development of the Jewish community in Northern Virginia and even precipitated discussions that led to establishing the Jewish Community Center. It has provided a Jewish environment for thousands of children from across the area, including many who did not have other opportunities for contact with Judaism. The shared experiences and friendships lasted a lifetime, and some even resulted later in marriages. Campers are shown here in 1986 role-playing a Jewish wedding ceremony. (Courtesy of Pozez JCC of Northern Virginia.)

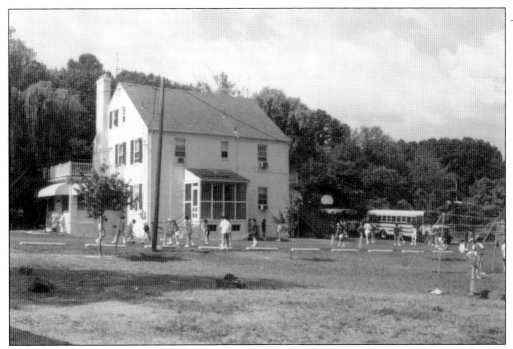

Camp Achva campers are engaged in different sporting activities in this 1986 photograph. The house seen in the background is the "White House," the first home of the Jewish Community Center of Northern Virginia. (Courtesy of Pozez JCC of Northern Virginia.)

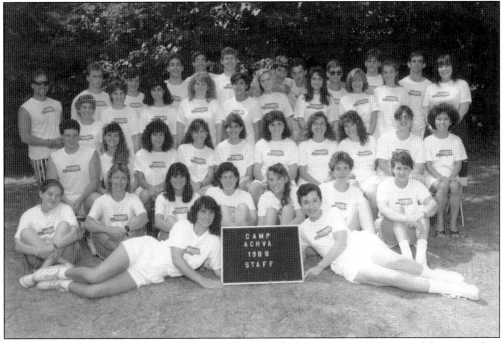

The staff of Camp Achva poses in this end-of-season photograph in 1988. Many of the counselors returned year after year. Lying with the sign are Gail Gordon (left) and Roz Engel, director of the camp. (Courtesy of Pozez JCC of Northern Virginia.)

Amnon Sheeloh, an Israeli fresh out of the Israeli army, joined Camp Achva in its first season to provide help with multimedia support, music, and Israeli folk dancing. Sheeloh eventually went back to Israel but in 2007 he returned to attend Camp Achva's 25th reunion at the Pozez JCC. At the reunion, he played some of the music from his days at the camp. (Courtesy of Pozez JCC of Northern Virginia.)

The strength of the bonds formed by campers was evident during the 25th anniversary of the camp's founding in 2007. In this photograph, former Achva camper Laura (Fuchsman) Adler and her husband, David, display a camp shirt that was signed by fellow campers and staff at the end of a camp session years earlier. Many former Achva campers have gone on to participate in and lead activities across the Jewish community. (Courtesy of Pozez JCC of Northern Virginia.)

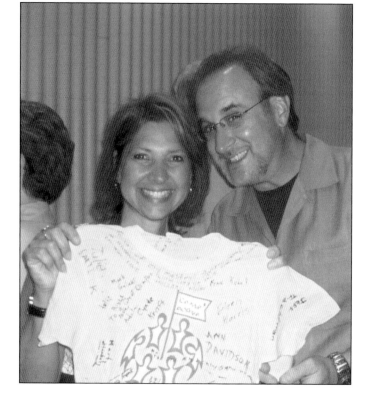

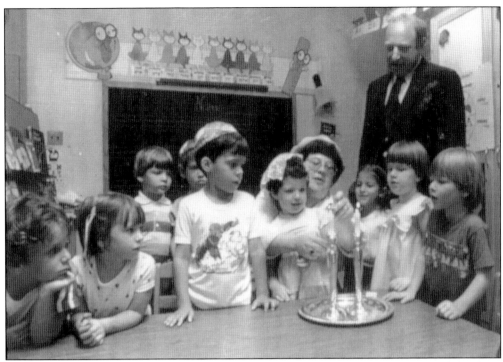

Gesher Jewish Day School is another institution central to Jewish Northern Virginia life. These photographs show an early Gesher classroom and students from the first Gesher class learning about Shabbat during the 1982–1983 school year. Teacher Susan Koss helps students light candles as Rabbi Sheldon Elster (standing on the right) looks on. The school was housed at Agudas Achim Congregation until 1993. As Gesher grew and needed more space, it relocated in 1994 to larger quarters in the Jewish Community Center of Northern Virginia. In 1998, Gesher again needed more classroom space and established satellite locations at the Chabad of Northern Virginia campus and also at Olam Tikvah. In 2002, Gesher purchased a beautiful 28-acre property in Fairfax. In 2007, Gesher moved into its new home at 4800 Mattie Moore Court (see pages 94–95). (Both, courtesy of Agudas Achim Congregation.)

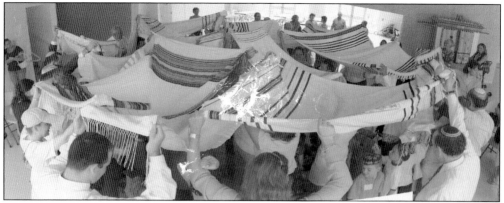

Gesher parents and students mark the 2010 school year with opening day festivities on September 10. The parents are holding *talitot* (prayer shawls). (Courtesy of David Massarik.)

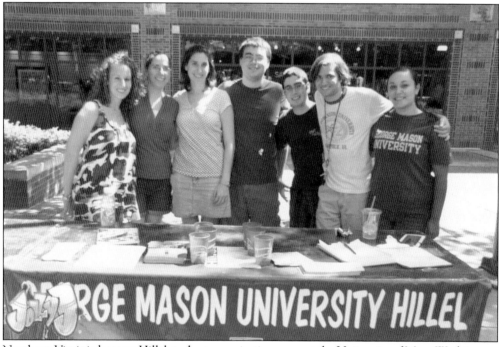

Northern Virginia has two Hillel student organizations: one at the University of Mary Washington in Fredericksburg and this one at George Mason University. Hillel is a student-led organization that supports and encourages the exploration of Jewish life and culture on college campuses through religious, educational, and social programs. Students in Hillel work to provide a community that helps Jewish students celebrate, learn, and explore their Jewish heritage. Prior to 1984, GMU had a Jewish Student Association (JSA). The associate director of the JCC, Scott Brown, led the effort to organize the JSA into the current Hillel chapter in that year. (Courtesy of Rabbi Daniel Novick.)

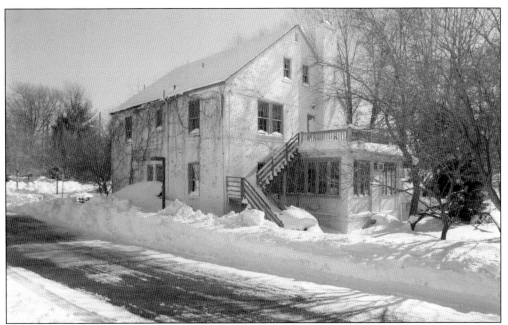

On May 9, 1980, the Northern Virginia Jewish Community Center (now the Pozez JCC of Northern Virginia) officially began operation, receiving a certificate of incorporation from the State Corporation Commission. Later that fall, the center's board of directors moved to purchase a temporary building on Little River Turnpike, which became affectionately known as the White House, seen in 2010. For 10 years, the building housed the Jewish Social Service Agency and the Jewish Council for the Aging, and provided a home base for Camp Achva. (Courtesy of David Massarik.)

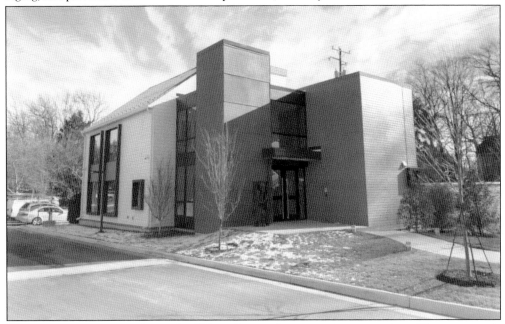

This contemporary view shows the White House after extensive renovations. The structure is now an annex to the Pozez JCC building and is named the Smith-Kogod Cultural Arts Center. (Authors' collection.)

Before the construction of the Northern Virginia JCC, community events were held offsite or in a temporary pavilion. One of the most heavily attended events was the Fair in the Square. This is a promotional flyer from the first of these annual fairs, held on June 17, 1984. (Courtesy of Pozez JCC of Northern Virginia.)

Many Northern Virginia Jews participated in efforts to protest Soviet government restrictions on Jewish emigration. Zelda and Jerry Dick (far left) organized this c. 1972 protest at the Soviet embassy in Washington. Other protestors include (in alphabetical order) Avram Ashery; Rabbi Marvin and Rebettzin Gila Bash; Michael and Pamela Dick; Bobbie, Dan, Andrea, and Joe Ebert; Isaac Fleishman; Michael and Laura Fuchsman; Alex Lieberman; Eric, Sonja, Deborah, Rebecca, Jules, and Jeanette Okin, and Don Sacarob. (Courtesy of Joan and Don Sacarob.)

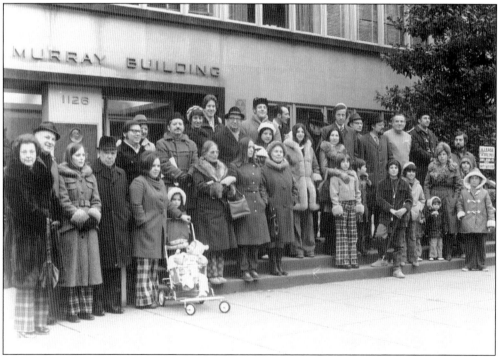

On December 6, 1987, a massive rally was held in Washington, DC, in support of Soviet Jewish emigration. The JCC and other organizations coordinated participation by Jews from across Northern Virginia in this landmark event. This photograph shows demonstrators in front of the Capitol building. (Courtesy of Congregation Beth Emeth.)

Ground breaking for the new JCC building occurred on March 29, 1987. Wielding the shovel is Phyllis G. Margolius, vice president for budget and planning at the United Jewish Appeal Federation of Greater Washington. At left is Jeff Karatz, director of the JCC. (Courtesy of the Fairfax County Public Library Photographic Archive.)

This photograph shows the JCC building under construction in October 1989. (Courtesy of Pozez JCC of Northern Virginia.)

The JCC is the focal point for a variety of social, cultural, educational, and athletic activities. This 1995 photograph shows a group preparing to participate in a Chanukah Torch Relay. Standing third from right is Ellen Oppenheim. (Courtesy of Pozez JCC of Northern Virginia.)

The JCC choral group the Mazeltones is shown preparing for a Chanukah concert in December 1996. Standing in the second row, second from left, is Victor Palchik. (Courtesy of Pozez JCC of Northern Virginia.)

Two of the flagship institutions of the Jewish community are Gesher Jewish Day School and the Pozez Jewish Community Center. In 2002, Gesher purchased a beautiful 28-acre property in Fairfax. In 2007, Gesher moved into its new home at 4800 Mattie Moore Court in Fairfax.

The state-of-the-art building (top) sits in an expansive wooded setting. The Pozez JCC building (bottom) is shown after a heavy snowstorm in 2010. (Both, courtesy of David Massarik.)

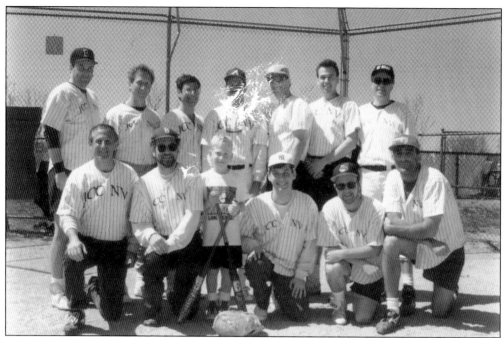

Amateur softball was serious business for the JCC of Northern Virginia team, shown in this c. 1993 photograph. The team was formed to bring Jewish athletes together, and many of the members remain close friends. They competed in Fairfax County leagues and won a few divisions and tournaments. A second JCC team, the Sabras, coached by Howard Frank, formed a few years later. From left to right are (first row) Ron Siegel, Mitch Baer, Andrew Thal, Seth Herz, Scott Brown, and Steve Karp; (second row) Randy Rubin, Ray Thal, David Berkowitz, Stuart Fruman, Dan Silverman, Tom Jackson, and player/coach Phil Dondes. (Courtesy of Pozez JCC of Northern Virginia.)

JCC's annual fundraising galas drew large community support. Pictured here is the cover of the 2004 gala program, co-chaired by Laura and David Adler and Elly and Ben Finkelstein. The evening honored Mayer Smith (of blessed memory) and presented the musical comedy revue *Forbidden Broadway*. (Courtesy of Pozez JCC of Northern Virginia.)

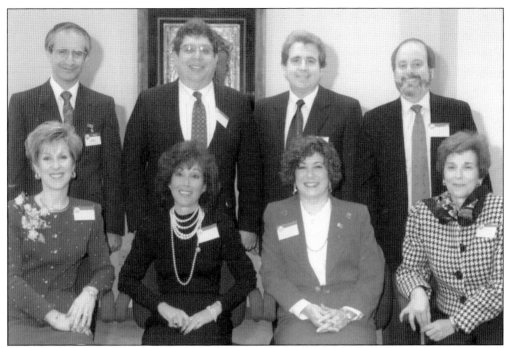

JCC past presidents pose in this c. 2010 photograph. From left to right are (first row, sitting) Trish "Pat" Kent, Joyce Grand, Bunni Latkin, and Adele Greenspon; (second row, standing) Jeff Karatz, Ben Finkelstein, Herman Hohauser, Chet Kessler. (Courtesy of Pozez JCC of Northern Virginia.)

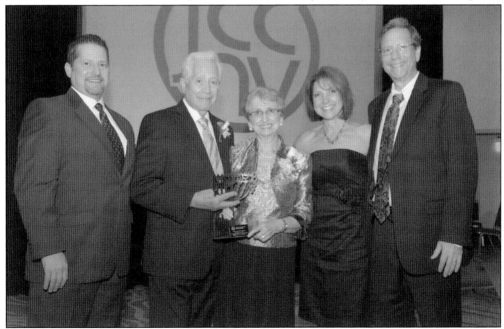

This photograph from the 2011 JCC Gala honoring longtime Northern Virginia Jewish community volunteers shows (from left to right) Michael Fuchsman, Alvin Fuchsman (holding award), Dotty Fuchsman, Laura (Fuchsman) Adler, and David Fuchsman. (Courtesy of Pozez JCC of Northern Virginia.)

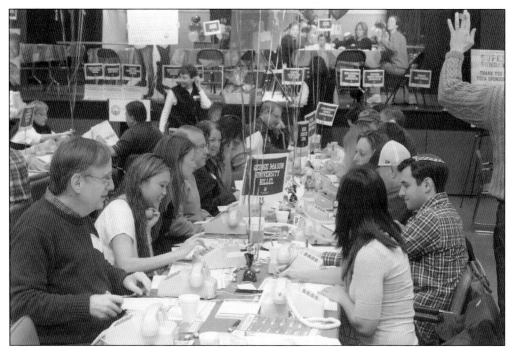

The Jewish Community Center hosted a fundraising event for the Jewish Federation of Greater Washington in 2010. That group supports organizations and activities throughout the region. Super Sunday is the single largest fundraising event of the year and brings together volunteers from Jewish groups across the region. (Courtesy of David Massarik.)

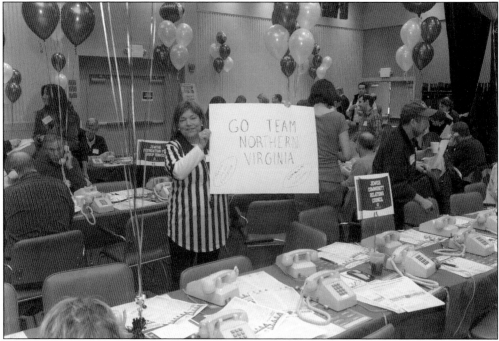

Carol Gordon, president of the JCC (wearing a referee shirt), encourages Super Sunday fundraising volunteers from Northern Virginia in 2010. (Courtesy of David Massarik.)

Six

NEW COMMUNITIES AND CONGREGATIONS

HAVUROT, RECONSTRUCTIONISTS, AND THE PIEDMONT COMMUNITIES

Northern Virginia is home to many small *havurot* (groups of friends), including Reston Shoreshim and Fabrangen West. Shoreshim is over 40 years old and describes itself as "a shul without walls, a vibrant and friendly havurah—a group of Jews who gather to facilitate Shabbat and holiday prayer services, and to share communal experiences." The Fabrangen West Havurah is an offshoot of the five-decade-old Fabrangen Havurah in Washington, DC. This photograph shows Bracha Laster of Fabrangen West demonstrating how to blow a shofar. (Courtesy of Bracha Laster.)

Kol Ami is the only Reconstructionist congregation in Virginia, adding creative new options for Jewish expression. Kol Ami began as a *chavurah* in the 1990s. In December 2000, the founding members hosted an open meeting to discover if there was enough interest to support a congregation or if it was time to fold. With over 60 attendees at the meeting, the *chavurah* had their answer. Rabbi Leila Gal Berner served the community as founding rabbi until 2016 when she was succeeded by Rabbi Gilah Langner. Here, Rabbi Langner leads a program in a member's sukkah during the holiday of Sukkot in 2019. (Courtesy of Kol Ami Northern Virginia Reconstructionist Community.)

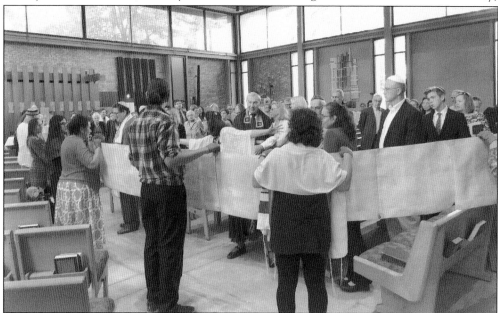

During a 2018 bat mitzvah, Kol Ami celebrated completing the cycle of reading the Torah and beginning again by unfurling its Torah scroll for all to see. (Courtesy of Kol Ami Northern Virginia Reconstructionist Community.)

Jewish military personnel and others working at Fort Belvoir have access to services at the Fort Belvoir Jewish Congregation, active since at least 1955. The congregation is supported by Jewish chaplains who serve their tours of duty at the base. This photograph shows a Torah procession inside the chapel, with the ark doors open in the background. (Courtesy of Fort Belvoir Religious Support Office.)

A soldier lights a menorah as part of a Hanukah program at Fort Belvoir Jewish Congregation. The Olive Oil Factory sign announces a program supported by the local Chabad Lubavitch. (Courtesy of Fort Belvoir Religious Support Office.)

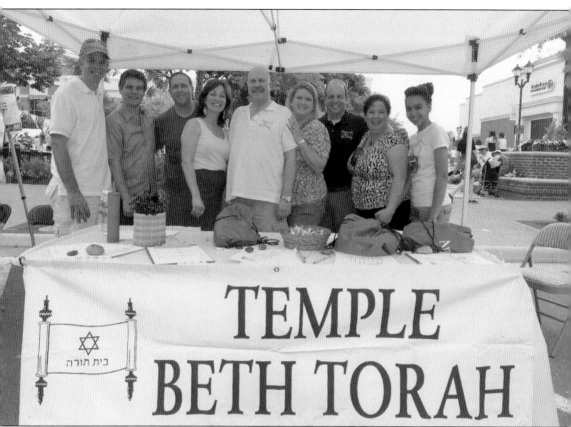

Temple Beth Torah members are seen here at the 2010 Israel-Fest celebration. From left to right are David Barondess, Joel Wasserman, Erick Kravchick, Ginny Marsh, Jeffrey Horner, Mary Horner, Matt Kestenbaum, Nancy Portee, and Brittany Portee. Temple Beth Torah formed in 1994 as the Centerville Area Jewish Community and took on its current name in 1999 when it affiliated with the Union of Reform Judaism. (Courtesy of Temple Beth Torah.)

In December 1966, a small group of Jews from the Reston, Herndon, and Leesburg areas held a Hanukah celebration at Lake Anne, marking the start of the Northern Virginia Hebrew Congregation (NVHC). The new congregation was the first Reform congregation in western Fairfax County. The congregation grew steadily, and in 1979 broke ground on its building, shown in this contemporary photograph. (Authors' collection.)

Places of Worship

a message from
Congregation Beth Emeth
Rabbi Kenneth M. Tarlow

Beth Emeth, Reston's first Conservative Jewish Congregation has recently been formed to serve the spiritual and educational needs of the Jewish community. The Congregation is an outgrowth of an informal meeting of several local families interested in exploring alternatives for Jewish education in the Reston area. At the first general meeting of the Congregation, a slate of interim officers was elected and plans were made for formal elections to be held in the fall.

Rabbi Kenneth M. Tarlow, a distinguished area clergyman, has been engaged as the spiritual leader of the Congregation. Rabbi Tarlow, Director of the Seaboard Region of the United Synagogue of America, will conduct the services for the High Holy Days to be held at Lake Anne's Fellowship House. He will also lead the

NEW JEWISH CONGREGATION FORMED IN RESTON

Congregation in its twice monthly Friday evening services.

The religious school will open in the Fall , offering a full program for

children of pre-school to Bar and Bat Mitzvah ages. Classes will be held Sunday mornings at the Hunter Mill Day School as well as on Wednesday (after school) for grades three to seven. The instructors are highly qualified professionals with extensive backgrounds in the area of Jewish education. Plans are underway for the creation of a youth group which will work along with existing national youth organizations in their activities.

On the social aspect, plans are being formalized for the creation of a men's and woman's club. An informal social to acquaint prospective members with the Congregation will be held at 7:30 p.m. August 19.

For more information about the Congregation or the social please contact Steve Sanders at 471-1664 or write to Congregation Beth Emeth, P.O. Box 2333, Reston, Va. 22090.

In the late 1970s, Conservative Jews in the Reston-Herndon area started organizing a new congregation later named Beth Emeth. This advertisement in the *Reston Times* ran on August 16, 1979, and announced plans for the formation of a religious school, Men's Club, Sisterhood, and High Holiday services. Response to the advertisement was overwhelming. (Courtesy of Congregation Beth Emeth.)

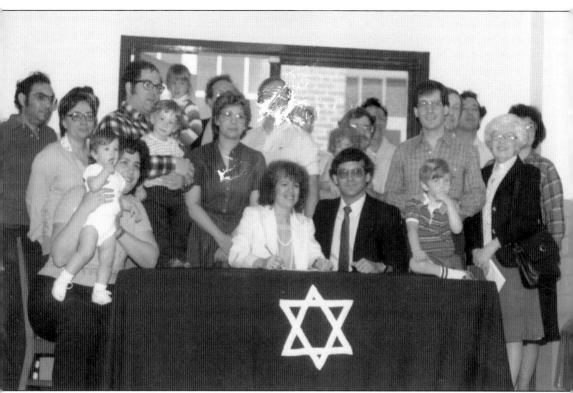

Congregation B'nai Shalom in Sterling and Congregation Beth Emeth in Herndon celebrated their merger at a ceremony in May 1983. Presiding were Gail Greenberg (seated, left) and Bob Leipzig (seated, right). The two congregations combined their Hebrew schools a year earlier. The merger brought together B'nai Shalom's 35 member families and about 100 families from Beth Emeth. The resulting congregation retained the name Beth Emeth and met at the Reston Community Center until land was purchased and the synagogue building opened in December 1988. The boy on the table at right is Ben Grossman. (Courtesy of Congregation Beth Emeth.)

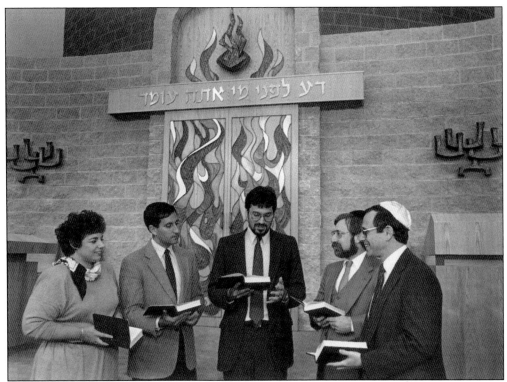

דע לפני מי אתה עומד

From left to right, Beth Emeth first vice president Shelly Kaplan, second vice president Jeff Skigen, Rabbi David Ebstein, president Jay Myerson, and business chair Ron Siegel prepare for one of the first services in the new sanctuary on November 9, 1988. (Courtesy of the Fairfax County Public Library Photographic Archive.)

The newly completed Beth Emeth building is shown here in late 1988. The building was dedicated in December of that year. A later addition significantly enlarged the building to add a social hall, religious school classrooms, and library. (Courtesy of Congregation Beth Emeth.)

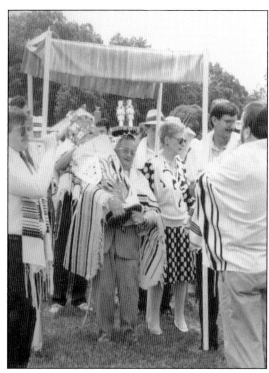

Edie and Harold Brownman, under the chuppah, lead a joyous procession to dedicate a newly inscribed Torah scroll to its new home at Congregation Beth Emeth in 1997. The chuppah is used to symbolize the congregation's joy when welcoming a new Torah scroll to the synagogue. (Courtesy of Congregation Beth Emeth.)

Rabbi Steve Glazer is seen here with an open Torah scroll in 2004. The rabbi served at Congregation Beth Emeth from 1995 to 2013, when he retired. (Authors' collection.)

Adat Reyim (A Community of Friends) was founded in 1981 to provide a warm and friendly spiritual Jewish home in southwest Fairfax County. The modern synagogue building was dedicated in 1989. Rabbi Bruce Aft served the congregation from 1991 until he retired in 2020. Rabbi Leslie Glazer is the current rabbi. This contemporary photograph shows the ark with eternal light above it. The Hebrew is inspired by Exodus 3:5, and translates as "Know before Whom you stand."

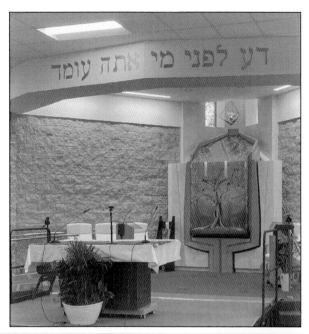

Jacob and Joan Cohn formed the first Jewish congregation in Prince William County in 1970, which became known as Ner Tamid (Eternal Light). About a year later, a second small group formed near Manassas, holding services in the Jackman family home. This congregation was later called Bayis Shalom (House of Peace). In 1985, the two congregations merged to form Ner Shalom (Light of Peace) with Rabbi Samuel Volkman serving as the first rabbi. By 1991, the congregation purchased this 10-acre parcel at 14010 Spriggs Road in Dale City. (Courtesy of Congregation Ner Shalom.)

The ground-breaking ceremony occurred in October 1993, and the building dedication was held on October 16, 1994. This photograph shows Rabbi Jonathan Katz and a congregant placing a mezuzah case on the front door of the new Ner Shalom building during the dedication ceremony. The mezuzah case, created by congregant Kyle Smith, contains a small parchment scroll with writings from the Torah. Standing from left to right are Neal Slater, Rabbi Jonathan Katz, Mike Mullen, and Don Rickey. (Courtesy of Congregation Ner Shalom.)

Rabbi Jonathan Katz leads a blessing over challah during religious services in this c. 1994 photograph. From left to right are Rabbi Katz, Cookie Tendler, and Ner Shalom president Scott Rittenberg. Tendler baked the challah. (Courtesy of Congregation Ner Shalom.)

Ner Shalom welcomed Rabbi Jennifer Weiner in 2004 after the departure of Rabbi Katz. In 2016, Rabbi Elizabeth Goldstein (pictured) succeeded Rabbi Weiner. (Courtesy of Congregation Ner Shalom.)

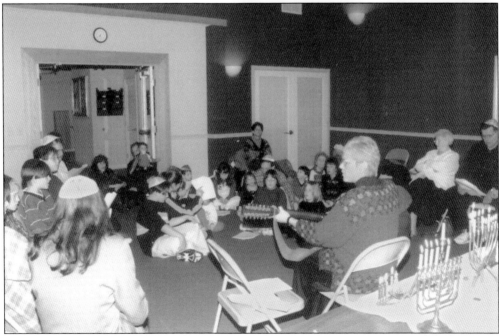

Jews have lived and worked in Loudoun County at least since 1840. It was not until the late 1970s that a few families met to form a Jewish community centered in Leesburg, but after 1978, some of these families left to join Beth Emeth in Herndon. In 1996, Sidney Lissner launched a second attempt that succeeded in forming a havurah called the Loudoun Jewish Community, renamed the Loudoun Jewish Congregation in 1997. This photograph shows Robin Kaplan (with guitar) leading a music program around 1998. (Courtesy of Congregation Sha'are Shalom.)

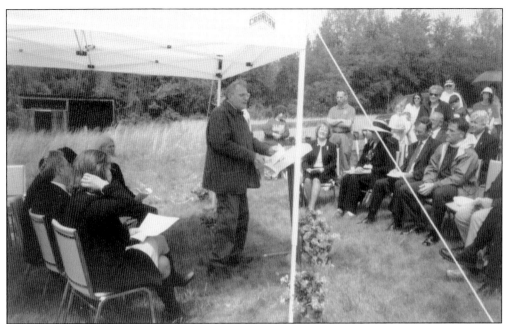

In the fall of 1998, Irwin Uran donated $2 million to purchase land and construct the first synagogue in Loudoun County. Uran is shown here speaking at the ground-breaking ceremony on April 28, 2001. Uran, an extraordinary man, was described as a reclusive multimillionaire often mistaken for a farmer. No one in the congregation knew the 72-year-old benefactor, and he never joined or even attended services in the new synagogue. His intention to build a synagogue specifically in Leesburg was due to the anti-Semitism that he endured in Loudoun more than once. He wanted a permanent structure for the Jewish community as a lasting foundation and to help non-Jewish citizens in Loudoun County to get to know and understand their Jewish neighbors. (Courtesy of Congregation Sha'are Shalom and Nessa Memberg.)

The Sha'are Shalom building was dedicated in February 2005. The nine-acre site is on Evergreen Mills Road in Leesburg. Today, this Conservative synagogue has an active preschool and religious school, Gesher (formerly Kadima), and USY youth groups. (Courtesy of Congregation Sha'are Shalom.)

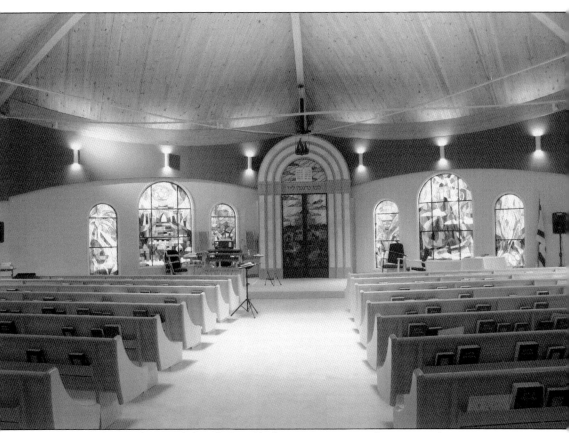

The extraordinary design of the Sha'are Shalom sanctuary can be seen in this contemporary photograph. The current rabbi, Neil Tow, served the congregation as a rabbinical intern early in its history. (Courtesy of Congregation Sha'are Shalom.)

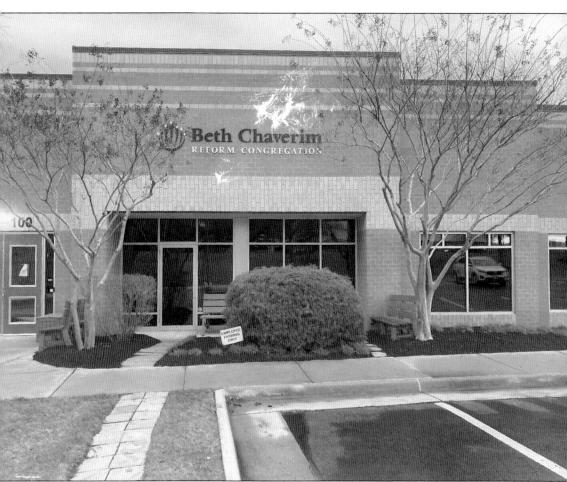

In 1997, Beth Chaverim was founded by five families centered around the Ashburn area in Loudoun County. The first services were held at the local Ruritan Club and in members' homes. In 2005, the congregation purchased property to serve as the permanent site of the Reform congregation. Today, the congregation meets in the leased space shown here in Ashburn. (Authors' collection.)

Seven

A FLOURISHING AND MULTIFACETED COMMUNITY

CHABAD AND THE RETURN OF TRADITIONAL JUDAISM

Since 1859, Beth El in Alexandria has offered worship services in the Reform tradition. Agudas Achim was Orthodox from 1914 to 1945, when it changed to Conservative. For the next 45 years, all synagogues in the area were either Reform or Conservative. Orthodox observance again became an option in 1991, when Chabad Lubavitch Rabbi Sholom Deitsch arrived. Before departing for Virginia, Rebbetzin Chani Deitsch and son Mendel receive a blessing and symbolic dollar from Rebbe Menachem Mendel Schneerson (of righteous memory) at Chabad Lubavitch headquarters in Brooklyn. The dollar was given to followers to use for charity. (Courtesy of Chabad Lubavitch of Northern Virginia.)

Chabad Lubavitch is an Orthodox Hasidic movement best known for conducting Jewish outreach. It sends emissaries (known as *shluchim*) across the United States and abroad to open new Chabad Houses. Chabad is named for the Hebrew words for wisdom (*chochmah*), comprehension (*binah*), and knowledge (*da'at*). Lubavitch is the town where the group was based for over a hundred years, and in Russian means "city of brotherly love." Rabbi Sholom Deitsch is leading an outreach effort at the Jewish Community Center in 1992, working as head matzah baker while his young assistants prepare the dough and learn about Passover. (Courtesy of the Pozez JCC.)

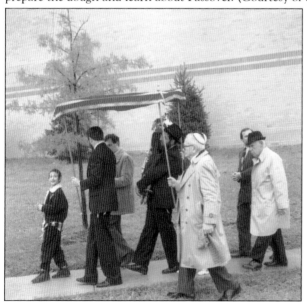

A major milestone and celebration for any congregation is the completion of a new Torah scroll. Chabad Lubavitch of Northern Virginia reached this milestone on November 1, 1992. Rabbi Sholom Raichik is carrying the Torah from the JCC building. Rabbi Noah Golinkin is helping hold the chuppah (in raincoat at center), and Isaac Fleishman is walking behind in the raincoat and black hat. From 1950 to 1965, Rabbi Golinkin was the rabbi of the Arlington-Fairfax Jewish Congregation. (Courtesy of Chabad Lubavitch of Northern Virginia.)

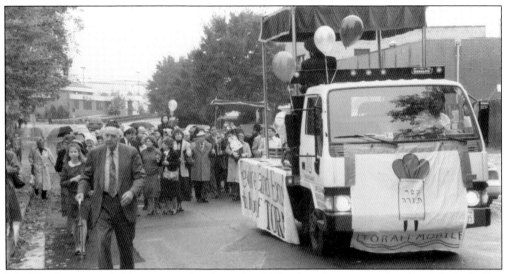

The Torah was carried in a procession from the JCC, where it was completed, to Chabad's first Fairfax location, a rented space at 9401 Mathy Drive. Chabad later moved to 9932 Main Street before purchasing its current campus at 3939 Prince William Drive. A Chabad rabbi is driving the "Torah Mobile." Howard Nachman, descendent of Julius Nachman (see chapter three), is holding the rear-left chuppah pole as part of the community procession. (Courtesy of Chabad Lubavitch of Northern Virginia.)

This portrait was taken at Chabad's Torah dedication in November 1992. The adults seated from left to right are Rabbi Sholom Deitch's mother, Brana Sheina Deitsch (of blessed memory); his father, Mordecai Deitsch; patron Isaac Fleishman; Sholom Deitsch, with son Mendel on his lap; wife Chani Deitsch; and her mother, Fay Kranz Greene. Others are extended family members. (Courtesy of Chabad Lubavitch of Northern Virginia.)

Rabbi Deitsch (not shown) and his wife, Chani, lead a Hanukah education and outreach event in 1993 at Tysons Corner Center Mall. Public Jewish cultural and religious programs, including prominent displays of Hanukah menorahs, have become commonplace since 1990. (Courtesy of Chabad Lubavitch of Northern Virginia.)

A Jewish tradition being observed again in Northern Virginia is the Upsherin, a ceremony marking a boy's first haircut at age three. Upsherin literally means "to shear off" and while widely observed by Hasidic Jews, the ceremony is also practiced by a wide range of other traditional Jews around the world. This 1993 photograph shows Rabbi Sholom and Chani Deitch with their son Mendel preparing for his Upsherin. (Courtesy of Chabad Lubavitch of Northern Virginia.)

Chabad bar mitzvah practices follow Orthodox customs. This 2003 photograph shows Mendel with his parents, Rabbi Sholom and Chani Deitsch. Mendel Deitsch is now a rabbi and served as the first head of the Chabad House at George Mason University in Fairfax. (Courtesy of Chabad Lubavitch of Northern Virginia.)

Chabad members are observing and celebrating the Brit Milah (bris, or ritual circumcision) of Dovid, son of Rabbi Sholom Deitch, on June 2, 2005. From left to right are Mordecai Deitsch (grandfather of Dovid), Mendel Deitsch (uncle of Dovid, holding the infant), and Dovid's father Rabbi Sholom Deitsch holding the prayer book. The renowned singer Avraham Fried is at far right. (Courtesy of David Massarik.)

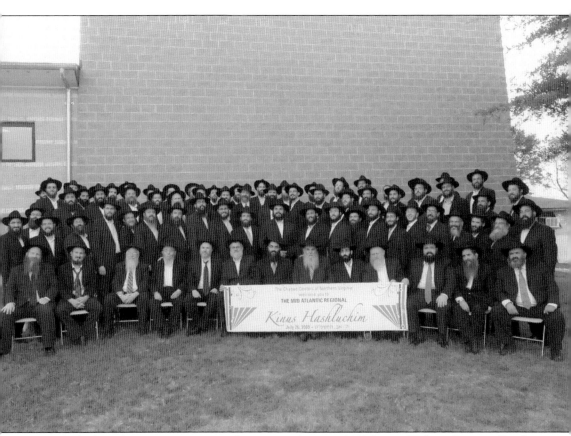

Chabad of Northern Virginia acquired its present home at 3939 Prince William Drive in Fairfax in 1996 and moved in a few years later. In 2009, the Mid-Atlantic regional meeting of over 75 Chabad *shluchim* (emissaries) was held in Northern Virginia for the first time. (Courtesy of David Massarik.)

One of many heavily attended and memorable Chabad-hosted community programs featured author Eva Schloss (right), shown here with Raizel Deitsch. Schloss is a Holocaust survivor and was a friend and neighbor of Anne Frank. Raizel is the wife of Rabbi Mendel Deitsch (see pages 113 and 116). (Courtesy of David Massarik.)

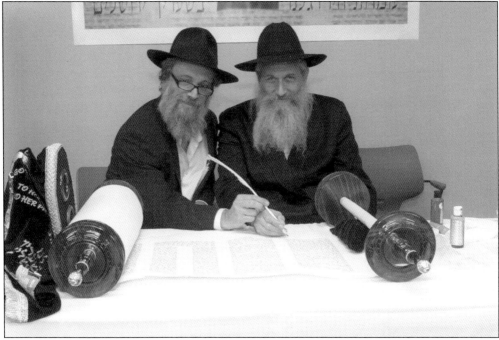

Rabbi Sholom Simon (left) poses while assisting a scribe complete a new Torah on September 18, 2016. Distinguished members of the community may be selected for the honor of helping the scribe to write a part of the scroll. Along with Olam Tikvah congregant Eliot Goldberg, Rabbi Simon headed the effort to construct the first eruv in Northern Virginia. The eruv is a symbolic boundary enclosing an area that allows observant Jews to carry some objects outside their homes on Shabbat. (Courtesy of David Massarik.)

Rabbi Chessy Deitsch from the Chabad Tysons Jewish Center carries the newly completed Torah from the Jewish Community Center to the Chabad Lubavitch Northern Virginia campus in September 2016. (Courtesy of David Massarik.)

The new Torah is seen here in a procession of vehicles on Little River Turnpike making its way to its new home at Chabad Lubavitch of Northern Virginia. (Courtesy of David Massarik.)

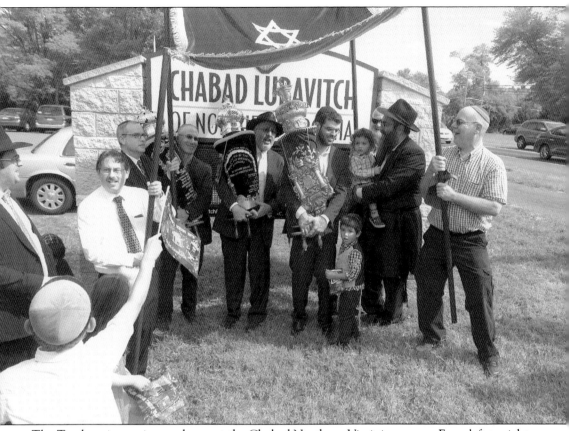

The Torah arrives at its new home at the Chabad Northern Virginia campus. From left to right are Ed Feltcorn (holding the front left pole supporting the chuppah), Steve Deichman, Mark Lapidus, Brian Gorin, Royi Zah, Rabbi Sholom Deitsch, Shmuel Anglester (partly obscured), and Glenn Taubman. The new Torah was donated by Brian Gorin. (Courtesy of David Massarik.)

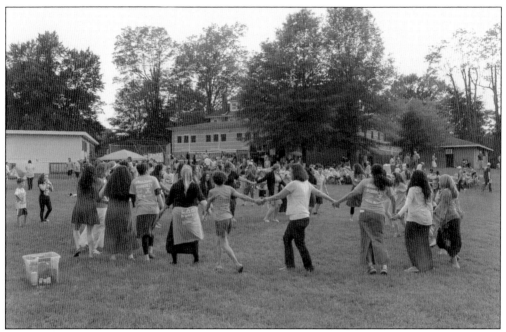

The Jewish holiday of Lag B'Omer may be celebrated with picnics, outings, weddings, and first haircuts for three-year-old boys. On May 26, 2016, Chabad hosted a community gathering to celebrate the holiday along with the JCC and Gesher Jewish Day School. The celebration included music, dancing, food, and sporting events. (Courtesy of David Massarik.)

Rabbi Mordechai Newman from Chabad Lubavitch of Alexandria-Arlington (standing on the right with hat) huddles with soccer team members during a break in the action at the Lag B'Omer community celebration in 2016. (Courtesy of David Massarik.)

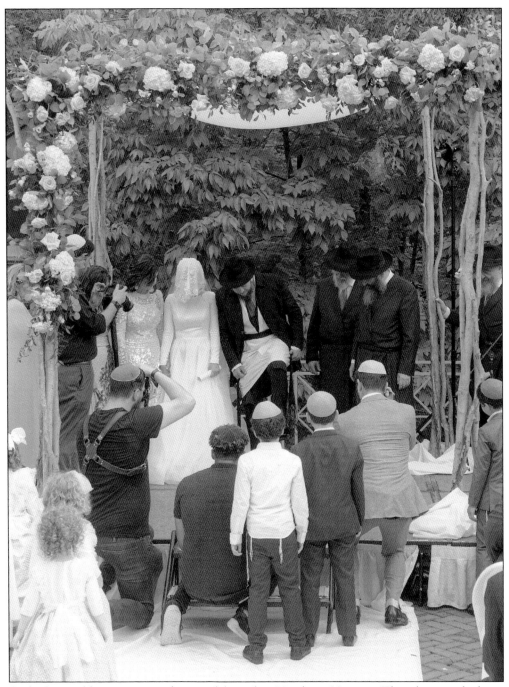

Orthodox weddings are again being celebrated in Northern Virginia. This photograph shows a wedding party under a decorated chuppah with the groom breaking the glass. (Courtesy of Sholom Deitsch and David Massarik.)

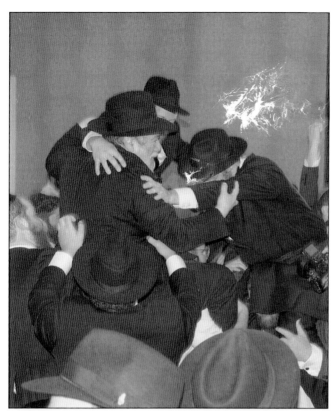

The groom (center) and his father (left) are seen in this photograph being raised on chairs at the reception celebration. The custom is a popular way to honor the celebrants and express joy. (Courtesy of David Massarik.)

This photograph shows the groom (wearing a suit at far right in the foreground) being entertained by his closest friends during the reception. This traditional dance originated in Eastern Europe and Russia and is a favorite at traditional weddings. (Courtesy of David Massarik.)

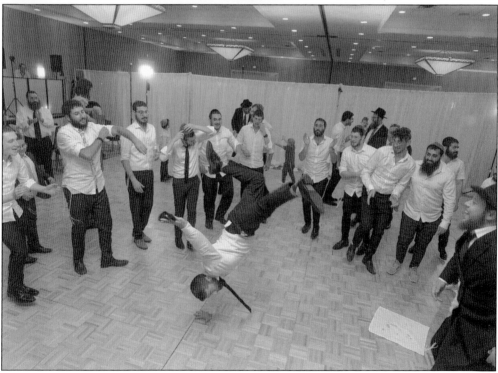

On March 24, 2002, the Jewish community celebrated the ground breaking of the first mikvah (ritual bath) in Northern Virginia since at least 1945. The mikvah is a central part of Orthodox Jewish life and its construction was a game-changer for traditional Jews in the area. The mikvah was opened for use on October 7, 2005. The Hebrew on the back wall is part of a prayer concerning the use of the mikvah. (Courtesy of Chabad Lubavitch of Northern Virginia.)

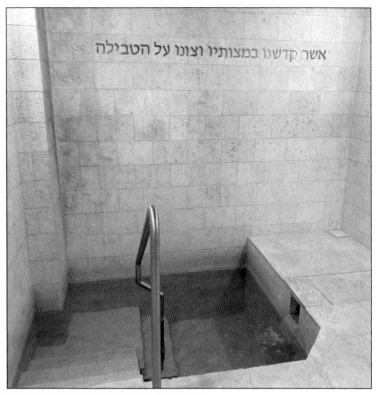

אשר קדשנו במצותיו וצונו על הטבילה

On December 19, 2021, the Jewish community of Northern Virginia registered another major milestone with the completion of an eruv around part of the community (see map on page 4). The eruv is a symbolic enclosure around a community that permits carrying some objects outside the home on Shabbat. The eruv is inspected every week before the start of Shabbat to certify that it is complete and intact. Eruv inspector Lucy Lapidus (seen here holding the Fairfax Eruv Manual) is preparing to make a round of inspections. (Courtesy of Glenn Taubman.)

Since 1991, Chabad has opened Jewish Centers across Northern Virginia in Alexandria-Arlington, Fairfax, George Mason University, Tyson's Corner, Reston-Herndon, Loudoun County/Ashburn, Gainesville, and Winchester. Rabbi Mordechai Newman, head of Chabad of Alexandria-Arlington, leads members of the local Jewish community as they accompany a new Torah to its home at Chabad of Alexandria-Arlington in 2006. (Courtesy of David Massarik.)

On the far western side of Northern Virginia, Winchester Rabbi Yishai and his wife, Bluma, stand in front of a Hanukah menorah during a public candle-lighting event in this recent photograph. Today, 165 years after the first congregation was established in Northern Virginia, the full range of Jewish services—Reform, Conservative, Orthodox, and Reconstructionist—is now practiced in our community. Jewish religious expression in the area has never been more vibrant, diverse, and multifaceted. (Courtesy of David Massarik.)

BIBLIOGRAPHY

Altshuler, David A. *The Jews of Washington, D.C.: A Communal History Anthology*. Jewish Historical Society of Greater Washington, 1985.

Encyclopedia of Southern Jewish Communities–Virginia. www.isjl.org/virginia-encyclopedia.html.

Friedman, Ruth. *A Portrait of Jewish Life: Fredericksburg, Virginia, 1860–1986*. Fredericksburg, VA: self-published, 1986.

Ginsberg, Louis. *Chapters on the Jews of Virginia, 1658–1900*. Richmond, VA: Cavalier Press, 1969.

Kenny, Robert W. *Temple Rodef Shalom: The First Twenty-Five Years, 1962–1987*. McLean, VA: Associations International, 1988.

Kuney, David R. *On Rockingham Street: Reclaiming My Family's Jewish Identity: Our Journey from Vilna to the Suburban South*. Eugene, OR: Wipf et Stock, 2021.

Liess, Enid. *Reflection and Renewal Beth El Hebrew Congregation 150 Years*. Alexandria, VA: Beth El Hebrew Congregation, 2009.

Marcus, Jacob Rader. *Early American Jewry: The Jews of Pennsylvania and the South 1655–1790*. Philadelphia, PA: Jewish Publication Society of America, 1953.

Rosenberg, Max. *A Centennial History of Beth El Hebrew Congregation*. Alexandria, VA: Beth El Hebrew Congregation, 1960.

Silver, Louis, ed. *Beth El Hebrew Congregation 1859–1984*. Alexandria, VA: Beth El Hebrew Congregation, 1984.

Urofsky, Melvin I. *Commonwealth and Community: The Jewish Experience in Virginia*. Richmond, VA: Virginia Historical Society and Jewish Community Federation of Richmond, 1997.

DISCOVER THOUSANDS OF LOCAL HISTORY BOOKS FEATURING MILLIONS OF VINTAGE IMAGES

Arcadia Publishing, the leading local history publisher in the United States, is committed to making history accessible and meaningful through publishing books that celebrate and preserve the heritage of America's people and places.

Find more books like this at
www.arcadiapublishing.com

Search for your hometown history, your old stomping grounds, and even your favorite sports team.

Consistent with our mission to preserve history on a local level, this book was printed in South Carolina on American-made paper and manufactured entirely in the United States. Products carrying the accredited Forest Stewardship Council (FSC) label are printed on 100 percent FSC-certified paper.

MADE IN THE USA